IF YOU KNEW ME
YOU WOULD CARE

IF YOU KNEW ME YOU WOULD CARE

BY ZAINAB SALBI PHOTOGRAPHS BY RENNIO MAIFREDI

FOREWORDS BY
MERYL STREEP, ANNIE LENNOX, ASHLEY JUDD, GEENA DAVIS

Foreword

Meryl Streep

One thing is inescapable in these pictures, and that's the connection that the gaze of each of these women makes with us. It is the frankest, most direct look; the way we look into the eyes of a sister or an intrepid friend. In our daily life we do not normally look, deeply, into the eyes of people we don't know. . . . It's too weird, too hard, too embarrassing; both of us unnerved by the intimacy and challenge of such a connection. But these photographs have a necessity and clarity that achieves that and more. They deliver dignity back to the person who looked at the camera, because we who turn the page and confront, in turn, each of these women, acknowledge each life, its size and importance, as somehow familiar.

The sitter is not robbed of her soul; she has expanded it out into the larger world, where we who are lucky to lock eyes with her, have the privilege to pay attention, give respect, and connect.

The unique approach of Zainab's book is that it has this mission. To remove the woman, the sister, the friend, from the circumstances of her victimization, and give her back her due respect as someone we recognize, someone we might know. This way of looking is with an activist's eye, and an open heart. Empathy, rather than sympathy, delivers these images to us, accompanied by a feeling that we are all in this struggle together. That it's up to us to stay alert to how similar we are, to how much we care about the same things in life. And how it is possible, as women, to find inspiration in lives outwardly different from our own. We are animated by the same dreams: hope for a better future for our children, hope for peace. This transaction, one to one, is how Zainab conceived of the organization she founded: Women for Women International. And it is that immediacy that this collection of photographs, and the stories they tell, makes tangible.

Annie Lennox

Throughout my life I've had an ongoing series of "Ah Ha!" moments that have changed the paradigm of my world view. The most impactful of these personal shifts came through my experience of becoming a mother just over two decades ago.

That was the point when I came to realize just how miraculous and vulnerable the manifestation of human life actually is. At that point I started to identify with other women as "mothers" like myself.

Mothers are the precious vehicles and entry points for the next generation of life. We bear the continuum of all human existence. So when we speak about human rights, we must surely endorse the notion that EVERY mother should be cherished, respected, supported, protected, and revered, no matter from which culture, creed, or position of economic or social standing. . . . As should every woman and girl.

If our basic values could simply uphold these principles, then the world would be a very different place. Human life would truly have value, and would not be squandered, abused, or debased.

The voices and stories of the women you are about to encounter in this beautiful book, belong to belong to "us all"—not "us" and "them."

We are all a part of the collective narrative.

Ashley Judd

While traveling together in eastern Democratic Republic of the Congo in 2011, Zainab showed me this remarkable collection of photographs and introduced me to some of the women pictured. What struck me immediately and viscerally is the sheen captured in the imagery, a gloss on the skin and shining liquid in the eye that is also present in person. I wondered if this very glow had its source in a desire to live—an internal force that cannot be captured or explained—despite wartime experiences and having every reason to want to die.

I am familiar with such desire. Suicidal depression was one of the ways I coped with unresolved childhood grief and the burden of generations of family pain. But then I received the gift of recovery. Through access to every modern mental-health healing strategy, and the dedication of time and resources, my painful past became my greatest asset. What used to hurt me is now a renewable source of tenderness, empathy, and desire to be of service to my fellows, which fills my soul with purpose and a sense of belonging to the human family.

And yet these women, going through more and worse than I ever did, did not kill themselves as they endured the unendurable, as they were subjected, for years, to torture. It astonishes. They have not had access to treatment centers, Twelve-Step Programs, or experiential therapy. Each time a new perpetrator raped her, each time she was made to watch others, including her own family, massacred, each time she suffered deprivation and horror . . . she lived. She lives with the haunting aftermath of trauma and the rending of life as she had known it: this, beyond the atrocities and inconsolability of war, moves and surprises me most.

We hear a lot about creatures having a desire to live, a powerful capacity to fight, to hang on. Tiny babies in neonatal units defy odds. Adults come back from being clinically dead. I recently sat in triage and then hospice with a dog who had been starved. In spite of his only human frame of reference being those who had hurt him, he bravely surrendered with trust to my care and kept soaking up love until his body gave out. But these creatures, unlike most of these survivors, experienced powerful external indicators that someone loved them, someone was passionately caring for them around the clock, and someone was fighting alongside them. Their will was met by equal action and effort by others.

So how can one explain where the desire and will to live comes from in those picture here? I cannot. It seems to me it can only be holy, sacred. It must be God in them. And it is both to them and to this profound mystery of strength that I bow.

Geena Davis

Looking at these photographs, reading these women's words, hearing their powerfully moving stories, one realization blazes brightest: these extraordinary women are not merely survivors of the unfathomable cruelties women are subjected to in conflict zones. They are flourishing—as witnesses, peace activists, survivors, negotiators, and leaders—with a *more* profound sense of dignity and of self than ever before.

Men *and* women need to see their faces and hear their words so that their world-changing stories can be shared across the world, helping to ease conflict and foster peace. Women are playing an ever-more important role in making the world a safer, more just place to live, and can do so much more if we can pay witness their courage and triumph.

Zainab's efforts to shine a spotlight on the overlooked role of women in war and peace-building—and to give those women's faces and actions and strength a place to shine—is an extraordinary accomplishment.

By truly seeing individual women, experiencing them, knowing them, we can empower and elevate *all* women. The women you will get to know in this book are role models for the ages.

Democratic Republic of the Congo

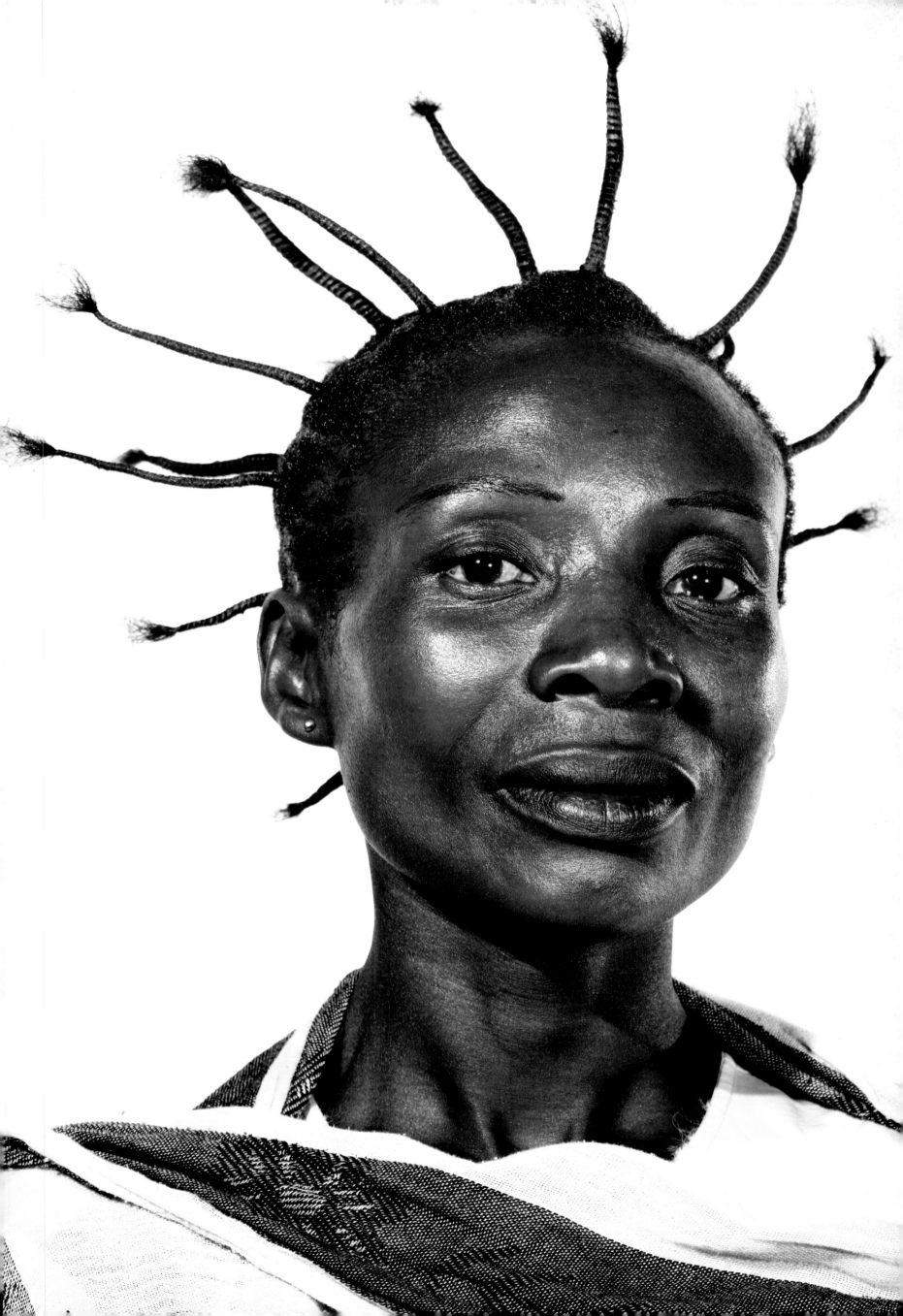

My name is Claudine

I was born in 1975. I wanted to be a doctor when I was young. But I had to stop secondary school when my father died. I was very sad and even angry to have stopped going to school but I had no choice as my mother was sick and I had to work to support her.

When I was 17, I met a young man on Sunday afternoon at Church. He was an orphan just like me and we loved each other. Ah love. I learned that love is a heart disease. We can't help ourselves when it happens. That man was the only man I loved in my life. We had a good marriage and were comfortable enough to have our children raised in a loving environment. But after a few years, he started hanging out with friends and started drinking a lot. Things got out of hand when one day he came home in the evening and started yelling at me and accusing me of spinning negativity on him. He took the pan in which I was cooking beans and he took it outside and threw it. In our custom, this meant, "I no longer want this woman in my house." And he took the lamp that was there and he started beating me and it was the beginning of our separation.

This was the very first time that it happened. But I was bleeding everywhere. The neighbors took me to the hospital and when I reached the hospital, the doctor said they couldn't treat me until I explained how it happened. They thought that it must have been road bandits who beat me so severely. I had no choice but to succumb to the doctors' pressure and tell them that it was my husband who did that to me. It was the very first time I was beaten and the last time that I entered that house.

I learned later that the doctors informed the police, who then went to arrest my husband for domestic violence. When he was released from prison a few days later, he accused me of sending the soldiers to him. He vowed never to share a relationship with me and kicked me out of the house. We loved each other a lot and maybe people, unable to tolerate our happiness, led him to drink and to reject me like this. I was left with my children whom I really love a lot. They also love me. But the problem is that there is no way to provide for their schooling. I was left with very little means when I went back to my family. I had to go to work on other people's farms to earn money to feed my children. It was very hard and I could only send the youngest two to school.

One day, I was going back home at around 7:30 in the evening. I encountered a soldier on the side of the road. He said, "Give me money." I told him that I didn't have any money; I only had flour to feed my children. So he said, "Give me money, or I will kill you!" At that time, I had no choice. He started beating me, and then he turned his gun on me; I thought he was going to kill me. Then he started to rape me.

I woke up in the hospital. Apparently some people saw me unconscious on the side of the road and took me to the hospital. That's when I also learned I was pregnant and was infected with an STD by this stranger. It was very hard to go back home and to deal with all that happened to me and my neighbors' gossip after seeing me pregnant. Eventually, I miscarried and I spent every penny I had on my medical bill. As a matter of fact, I am still paying for it.

That's when joining a women's organization saved my life. The women who were in my group and the trainers came to visit me, showed me love and care, and were my only comfort during those days. We love each other in the class and when we are all there, we are very happy. We are like sisters.

Today my wish is for no man to enter my life. All I want from God is to open doors for me so I can get food for me and my children on a daily basis. If I am weak today, it is because of men. After what I went through, I lost a lot of blood; they had to put extra blood in my body. As a result, I no longer feel like I am a human being; it's all because of men. I think I may be able to forgive this one day, because I could have died but instead I was saved. I am sure others have also forgiven.

One day I decided to speak out about what happened to me. It was something I never planned, inflicted on me by someone I never knew. And then I became pregnant and miscarried. All this made me angry and I said to myself, "I can't keep this anger in me, I have to speak out!"

I know that I should take courage because I survived a hard situation. Every day, I have to wake up and pray and say, "Thank you God, for I'm still alive. It was hard but now I'm here."

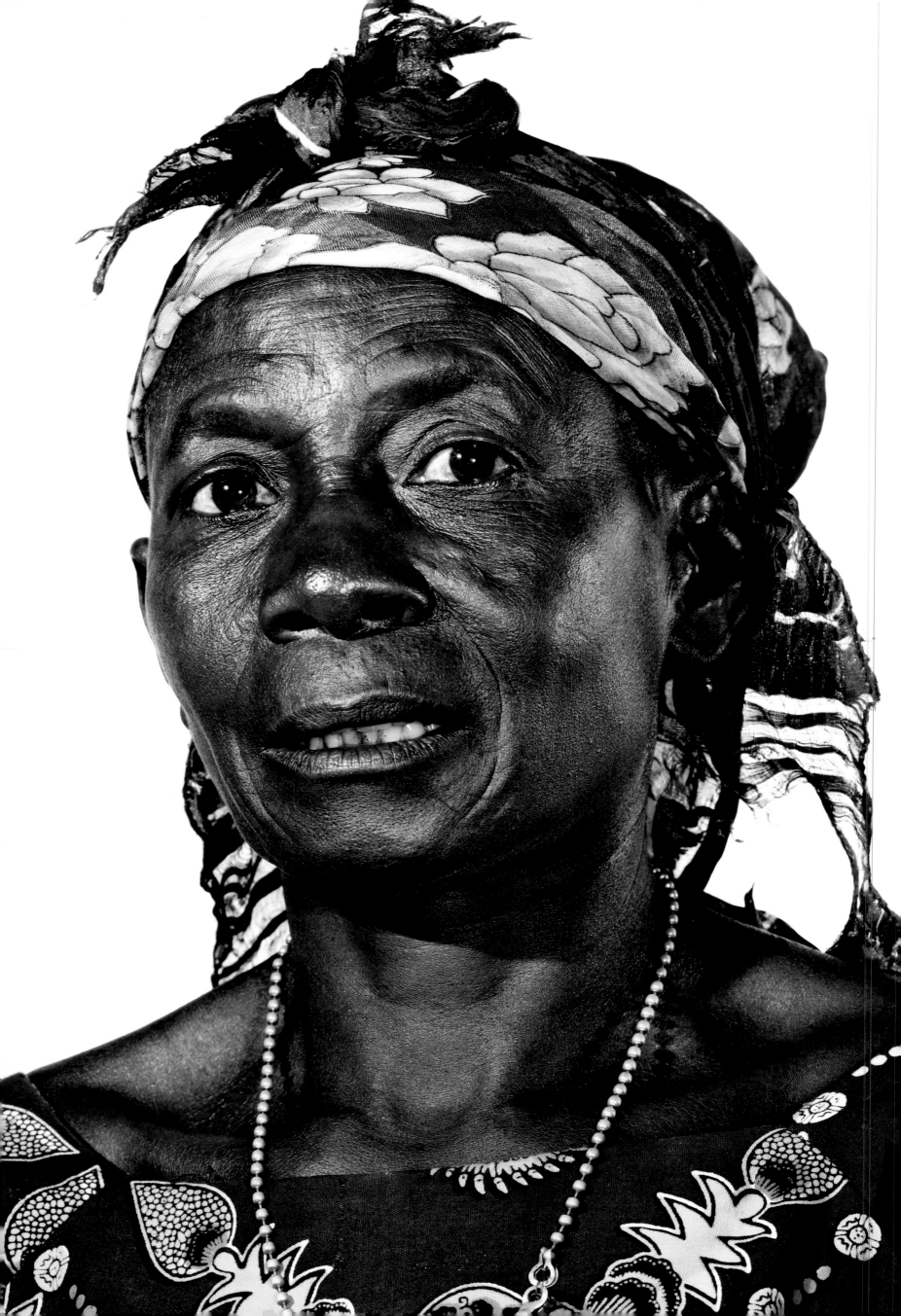

War means
misunderstanding.
People run away
to escape death.

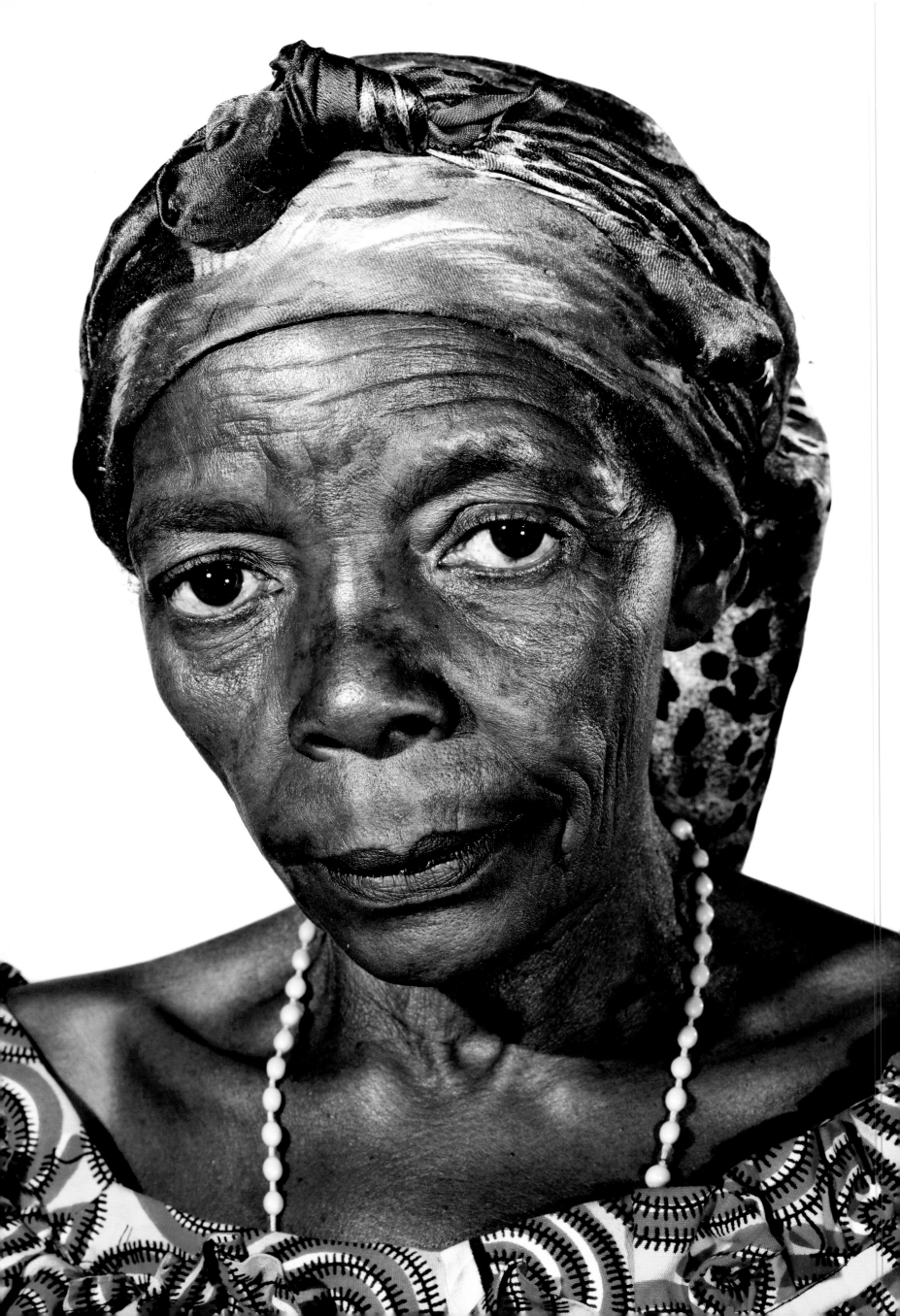

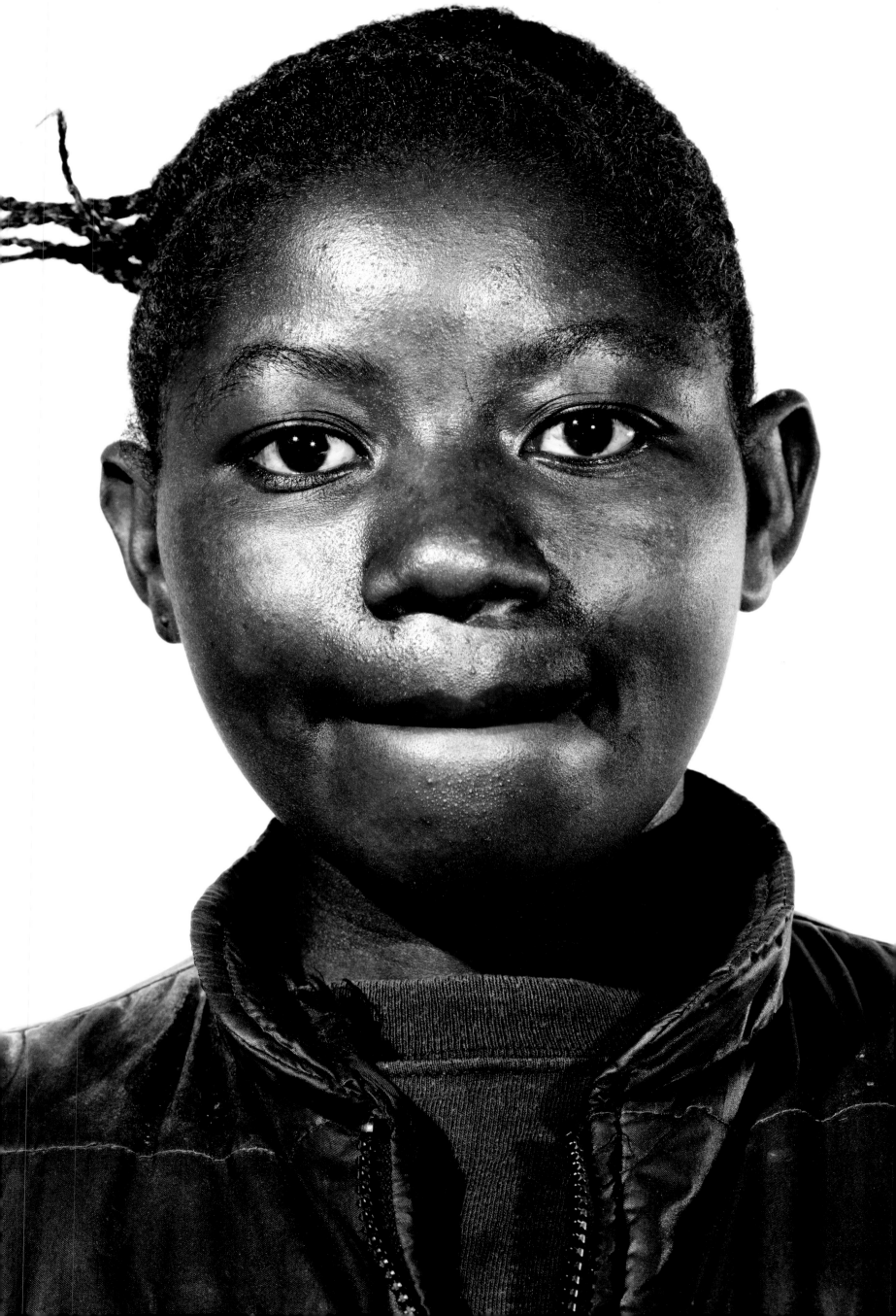

My name is Euphraise

I was born into a family of six of whom four were boys and two were girls. But all four of the boys died and eventually my parents died too.

I studied up to fourth grade in elementary school. My dream was to become a nun but unfortunately my father's poverty didn't allow me to finish my studies, which I needed to do to be enrolled at the convent.

So I got married instead. I was 18. So many men came to my parents and met me at my home. But one of them said that he loved me. And I loved him. So, I told my father, my parents paid the dowry, and we got married.

I gave birth to 17 children but eight passed away and only nine are alive. I was giving birth to children on a yearly basis. Every year I was delivering. When I reached the 13th, I underwent surgery but that child died and from then on, all the children that came after were stillborn; I was giving birth to dead, dead babies, dead babies until the end. And the 8th, 9th, and the 10th didn't survive.

After those children died, the event, the curse one might say, descended on our country, on our village, and we went through many things. At the time, both my husband and I were business people and we were doing well financially. We had our work, our belongings, and our animals—cows, chickens, goats you name it. But one night, at around 9PM while my husband and I were sleeping, people came into our house. They knocked and they entered our house. They looted everything from us. We had nine cups and they took all of them. They took all my clothes too. And all our cows.

And they beat me. And they raped me until I was about to die. It was one man but it felt like there were 10 or 15 men in one.

They beat one of my sons. One of them wanted to kill him and another said, "No. Since you are leaving his mother half dead, let him be. His mother will not survive." So they didn't kill him.

They didn't beat my husband. In fact, he was complicit; they had tied his hands behind his back and, after they beat me a lot and I was weak and they started raping me, he said, "Please, they are killing people. They will also kill you. Don't resist."

After the rape, people in the village thought that I was dead and there was talk of a man who was responsible for bringing those bandits into the village. Very late one night, that man walked into the village and when the village men saw him, they attacked and killed him. He lay there dead and no one in the village would bury him. Finally, the Red Cross came and buried him.

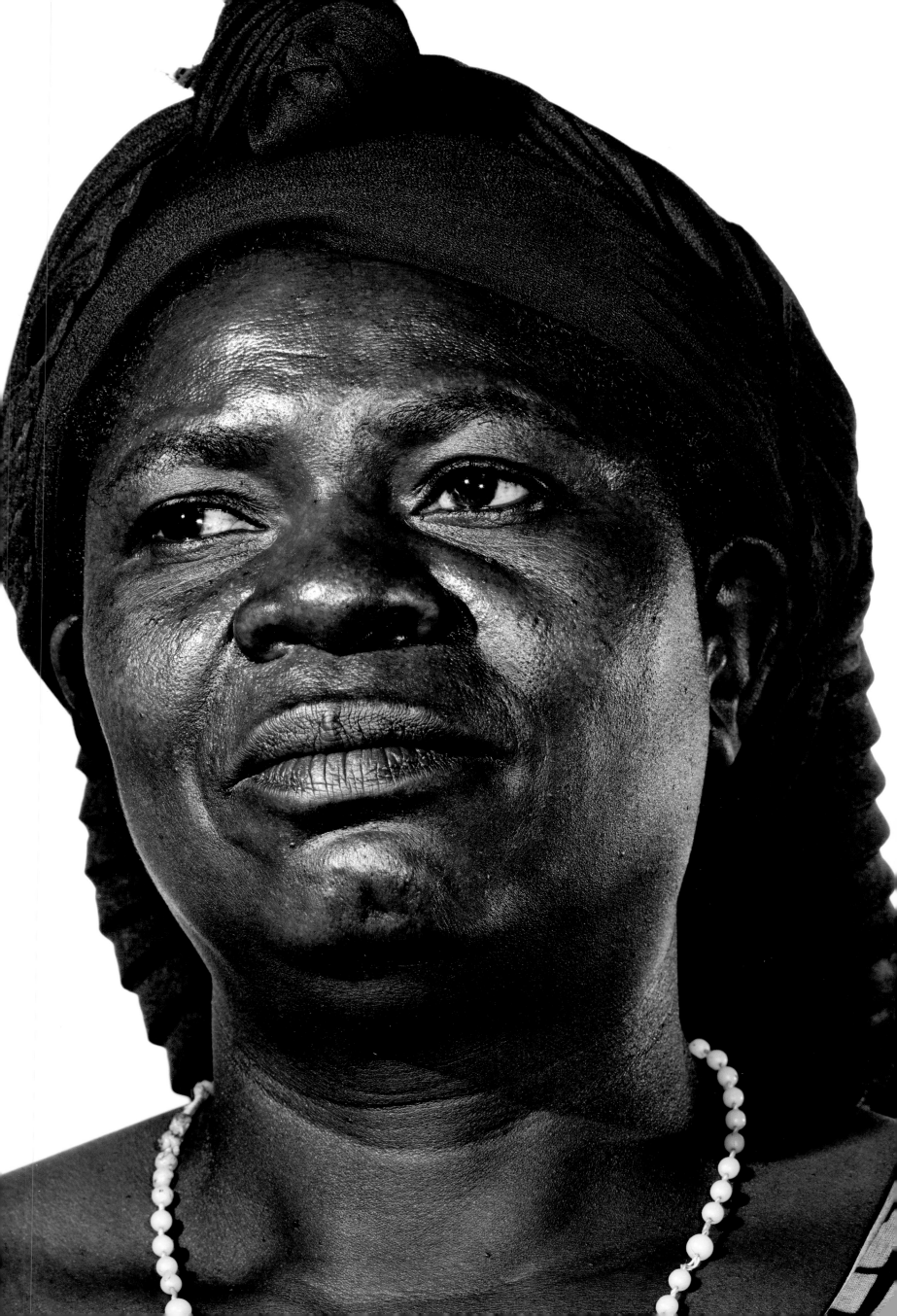

Don't look at me
as a poor woman.
I was a wealthy woman
once with cows,
goats, and chickens.
The war took all of that
from me and my
family. But I was
able to rebuild it
and now I am a
businesswoman again.

The night I was raped, I was saved by the priest from the parish of Kabahe. He came and took me from my house because I was vomiting blood and urinating blood too. And he took me to a center where I was treated. I was half dead but today I'm alive and I'm healthy. This is thanks to many people around me, the priest, my family, and Women for Women International. I received a lot of training on a lot of topics, and it helped me emotionally. It showed me that one may miss things, but when you still have heart, you still can think, you still can walk, then you still have strength and there is a way. After the attack, I couldn't speak. Whenever I speak about it, it's as if those bandits are coming for me again. It's like a revival of the event, but the training I have received has helped me a lot. I got emotional support and even financial support and was able to restart my business of breeding and selling livestock, and my children are going to school.

Through the sponsorship program, I exchanged letters with a woman in another country. My sister. Her name was Vivian. I graduated from the program three years ago. We lost touch after that. But if I could send her a message now, I would tell her that the money she sent me on a monthly basis and the training I received were fruitful. I would tell her that I am living in harmony with my husband, and that four of my children are grown up. I would tell her that a cow I own recently gave birth to another one, so I have two cows, four goats, and three plots of land, and I gave one to my son-in-law.

If I may come back to the origin of what I have gone through and why I am here, I would say it is having a good heart. I didn't hesitate to help people even when I didn't have much. When my brother fell sick and needed to go to the hospital, I only had $280 for me and my family. I decided to spend it on his hospital care even though I really needed the money for my family. He was so touched at what I had done and the fact that I was the only one who stood up for him in his dying days, he called a family meeting just before he died. In that meeting he told everyone how it was me who stood by him and to acknowledge me, he was leaving me his only cow. It is a big honor in our culture to have inherited from my brother. My husband and everyone else are grateful and proud of me. My husband had previously lost all of his cows, and now I have brought cows again into his compound, and it gives me some value in his eyes.

You know, money matters. Money means a lot. Before joining the program, I was useless, with no value. People were pointing at me. But now that I earn money, I have value. Now people consider me; the fact that I'm touching money, the fact that I'm using money, gives me some value. Both inside and outside the family, I now get some consideration.

And now I am a businesswoman.

Peace means love.

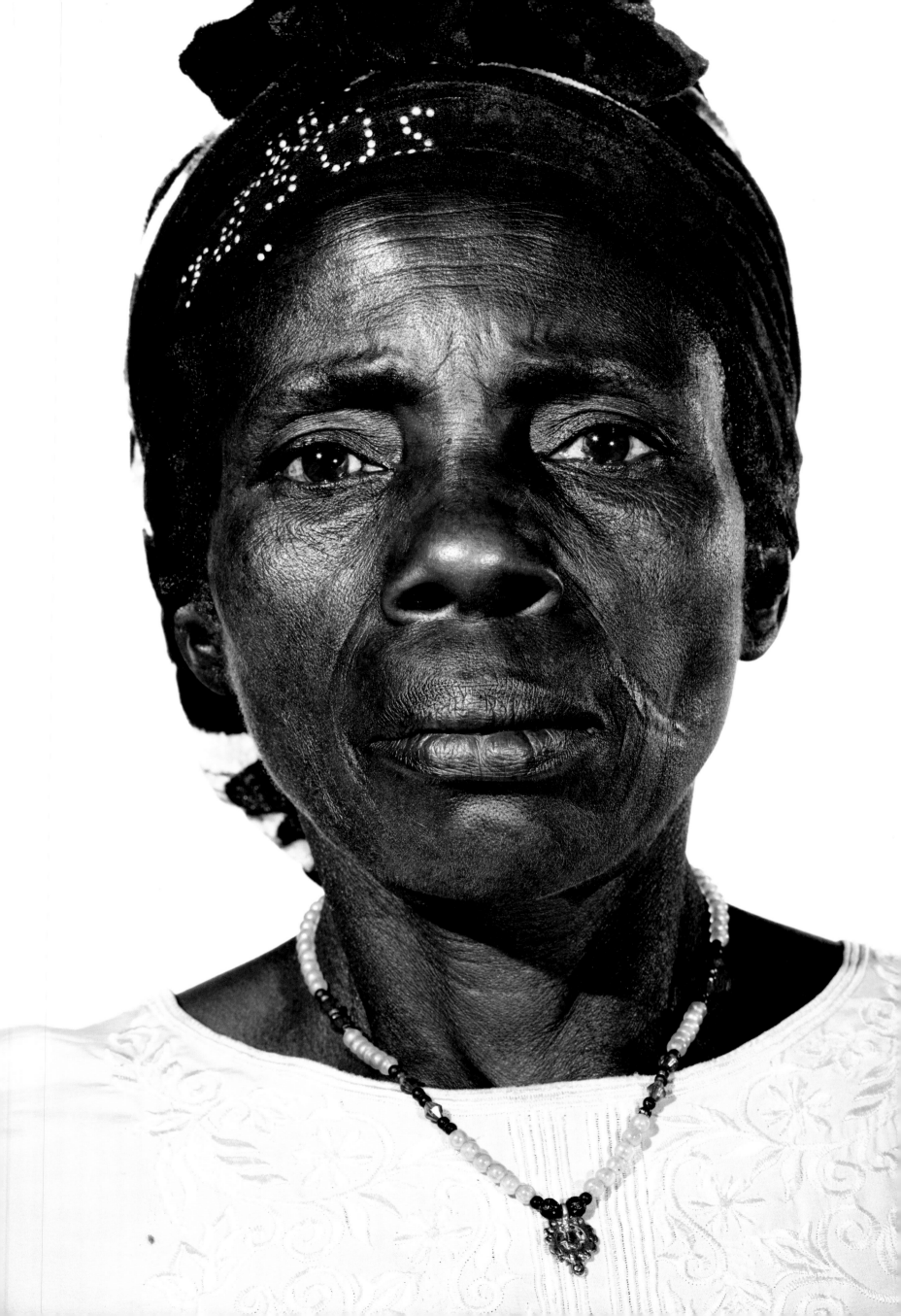

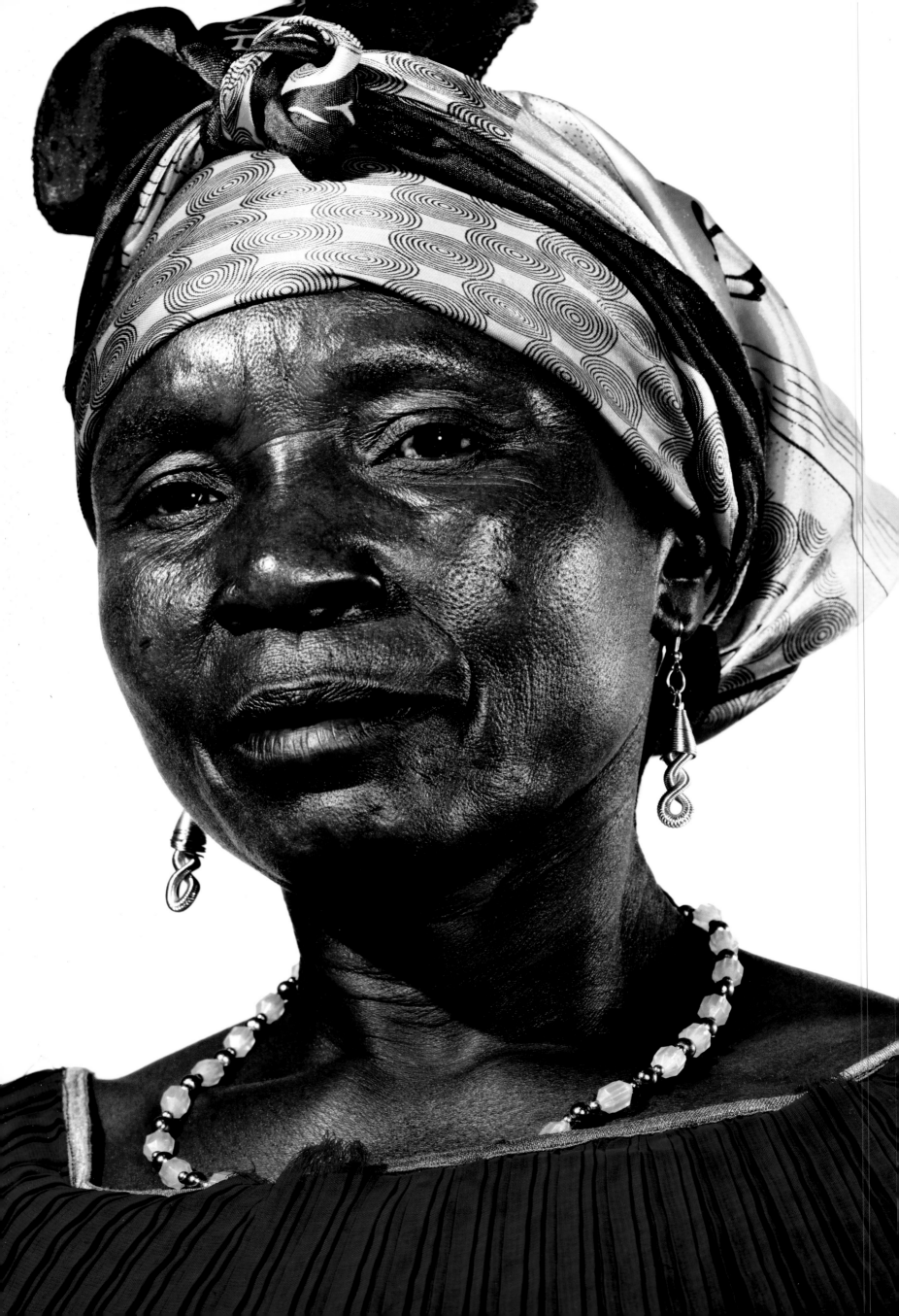

My only dreams
are to be able to feed
my children and
get the means to
send them to school
so they can have
open minds.

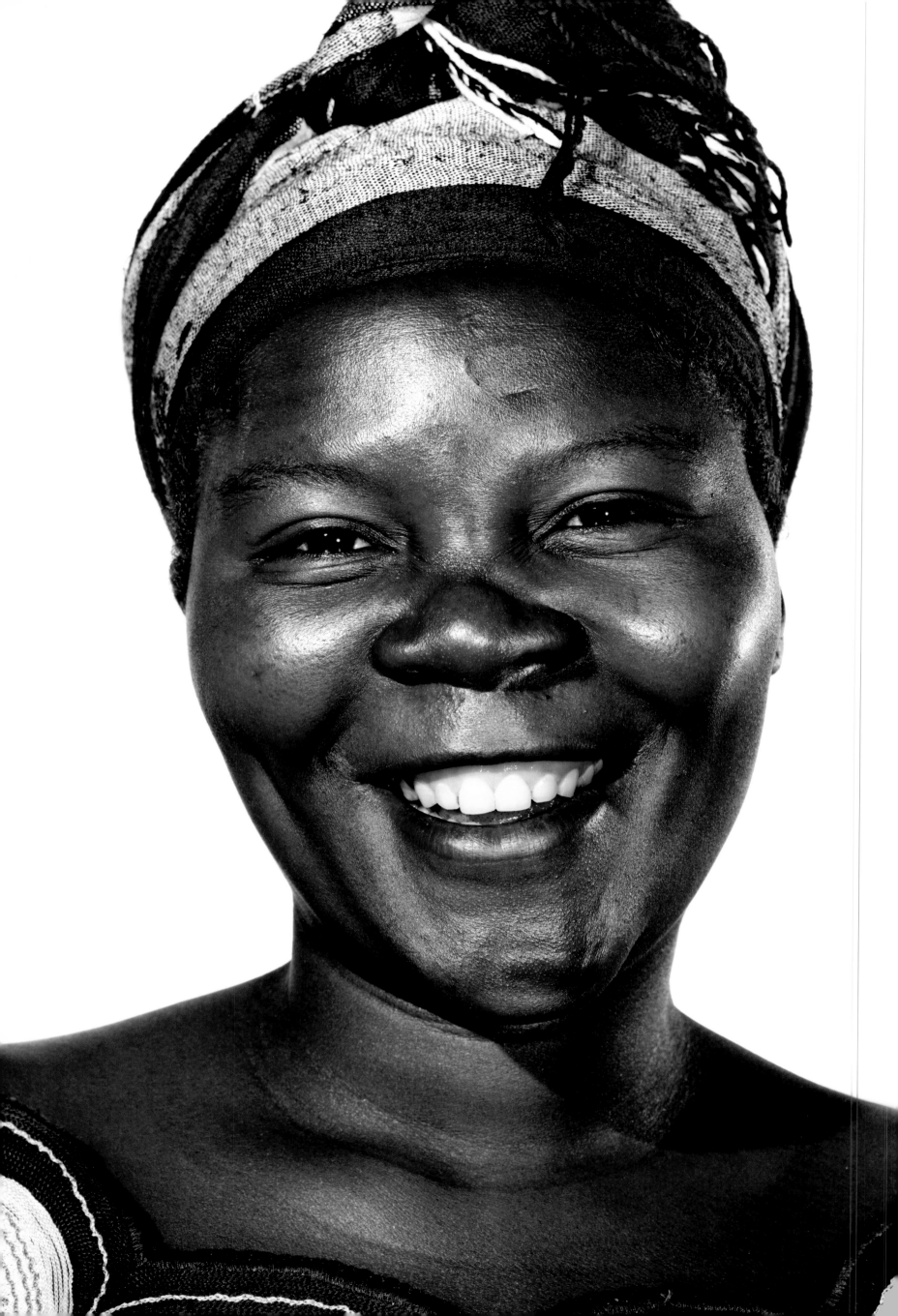

an organization that would help me, but, in my situation, I could not because everybody would be pointing at me and saying, "This is the wife of an Interahamwe."

So I stayed home praying and, after seven months, I delivered my daughter. For the next three years, I had a very hard life. The father of my first three children did not care about feeding his children. He would send only clothes. So to help them survive, I would carry gallons of beer to get paid 300 Congolese franks (about $0.30 U.S.). That is what I could find to pay for cassava flour and palm oil. And I found that I could go into the field to collect some vegetables to cook for my children.

When my youngest child was three years old, I heard people in my community saying that there was a women's organization that helped socially excluded women. I joined. They provided training that interested me. The first topic, which was the most interesting for me, was that a woman should value herself. A lady came and spoke to me and gave me a piece of advice that helped me a lot. She asked me not to neglect myself but to consider myself a person among others.

I also got vocational skills training, so that I could meet my needs and those of my family. I learnt about trade; I learnt how to avoid loss, how to make profit, and the different calculations.

I'm really thankful to my sponsor because thanks to her assistance, I've already been able to improve my house and I am saving $15 U.S. for my small business—I purchase bananas, use them to make local banana beer, and then sell the beer. This group is like a parent for those with no parents. My youngest daughter has no father. She was abandoned but I know that she is going to grow up well. It has not been easy to feed her, to school her, and to pay for her medical fees. But she is the best thing—both to me and my neighborhood. Though it hasn't been easy, I didn't lose anything; on the contrary, I gained. When my child is with me, I don't experience negative things. The child that I conceived out of rape is my prophet. She helps everyone around her and I know she will help me when I can no longer stand on my feet. Sometimes she takes food from the home and helps me to sell it to people near the roadside. For me, that child is extraordinary. In the process of raising her, I learned to find peace inside my heart. No one can give it to me. No one can take it away from me. Peace is inside my heart.

What helps me deal with what I went through is the knowledge that I am not alone. Those who keep encouraging me give me the courage to continue.

The advice that I give to others is that we have to be in touch with other people. This helps a lot because you may listen to what they say and that can bring some inner strength. They can give you encouraging words. This helps you and can heal internal wounds. And this is what I believe in and I know that God is there and when you trust in Him, He is going to give you the strength to overcome.

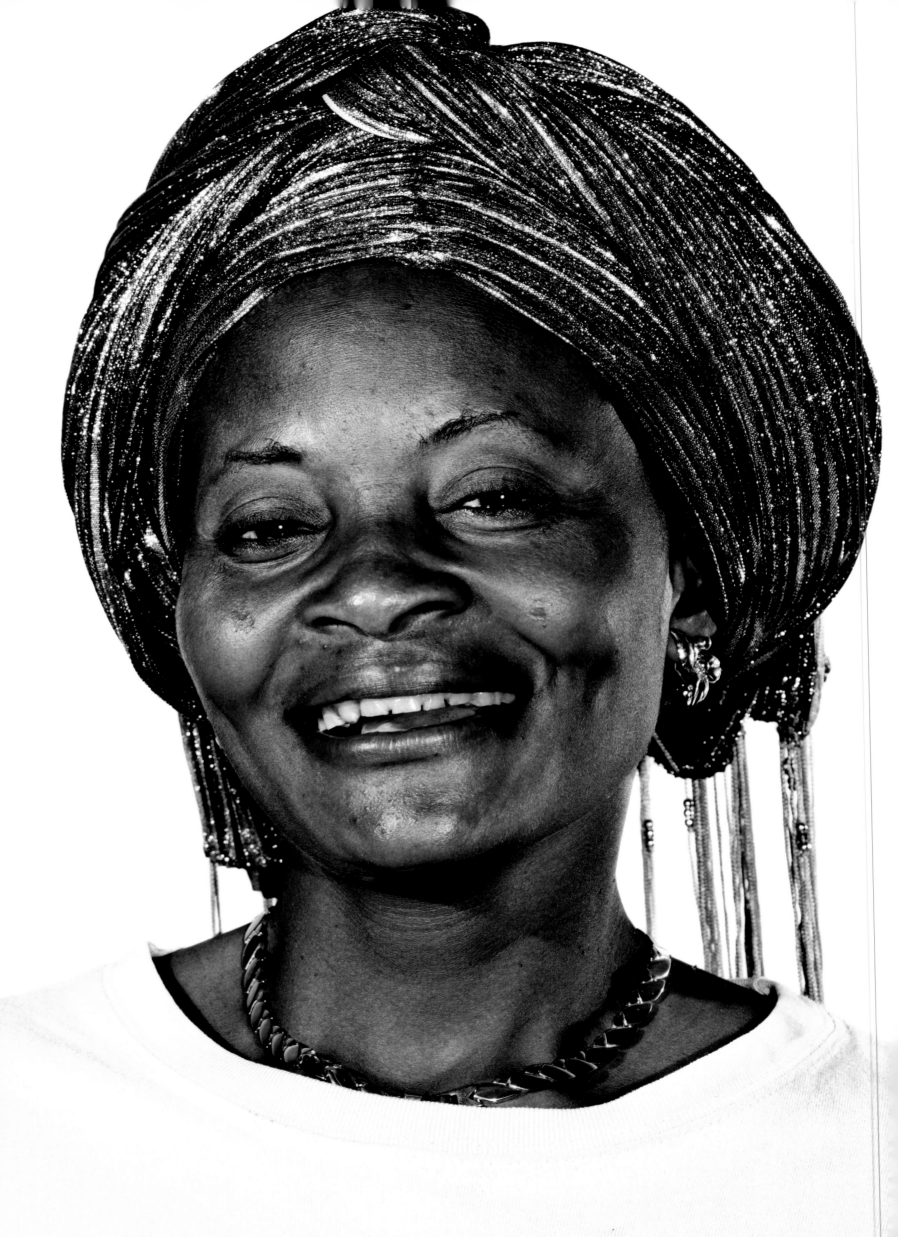

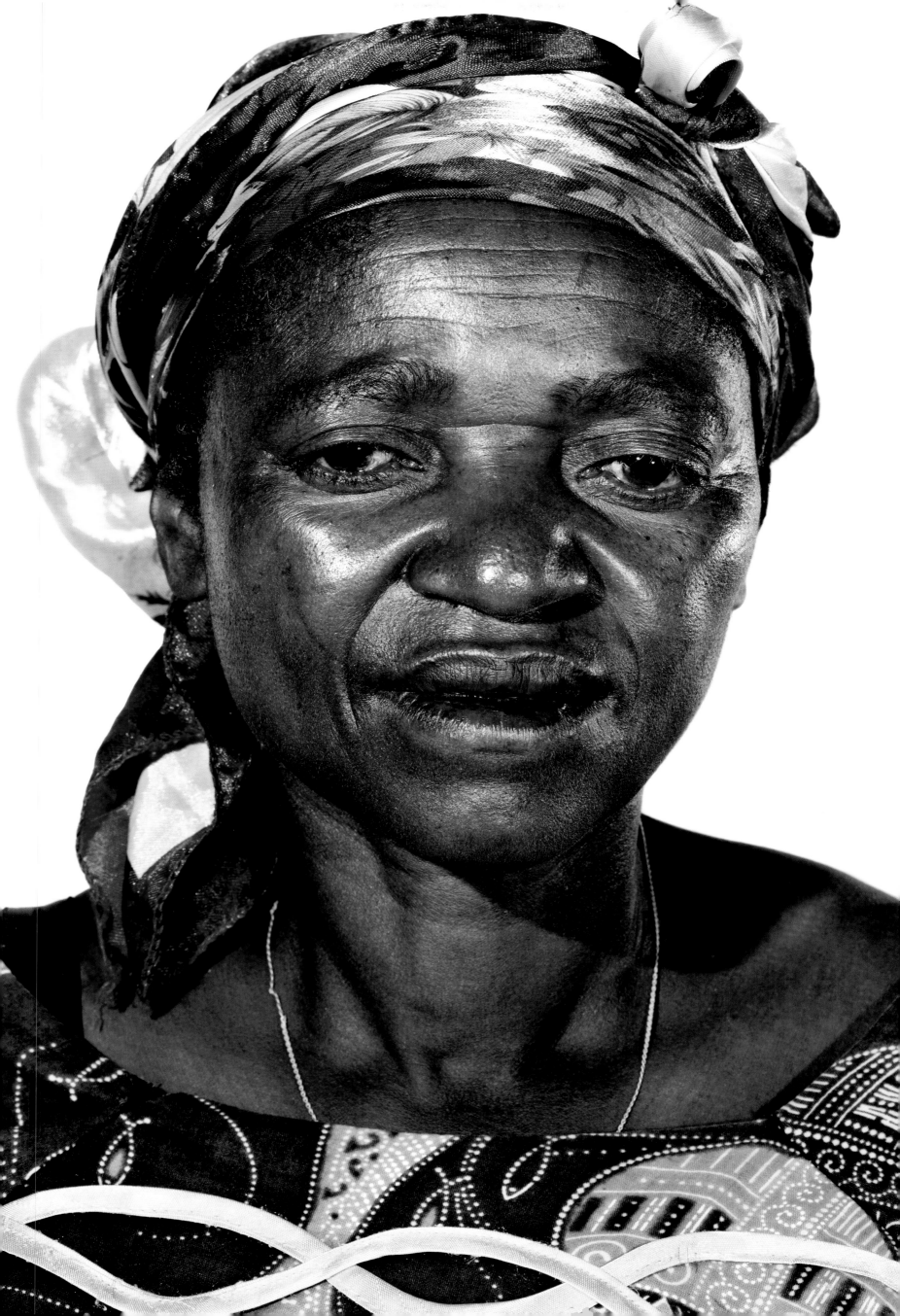

I was happily married with four children when rebels entered our home one night, separated me from my husband and children, and four men raped me many, many times. They cut my wrist and dug the knife in it. You see my scar? The neighbors took me to the hospital after the rebels left. When I came back it was early in the morning and still dark. I stepped on something. I didn't know what. When I turned on the lamp, I saw blood everywhere. That's when I saw the corpse of my husband. He was cut in the belly in two halves. I didn't even hear his cry when he died.

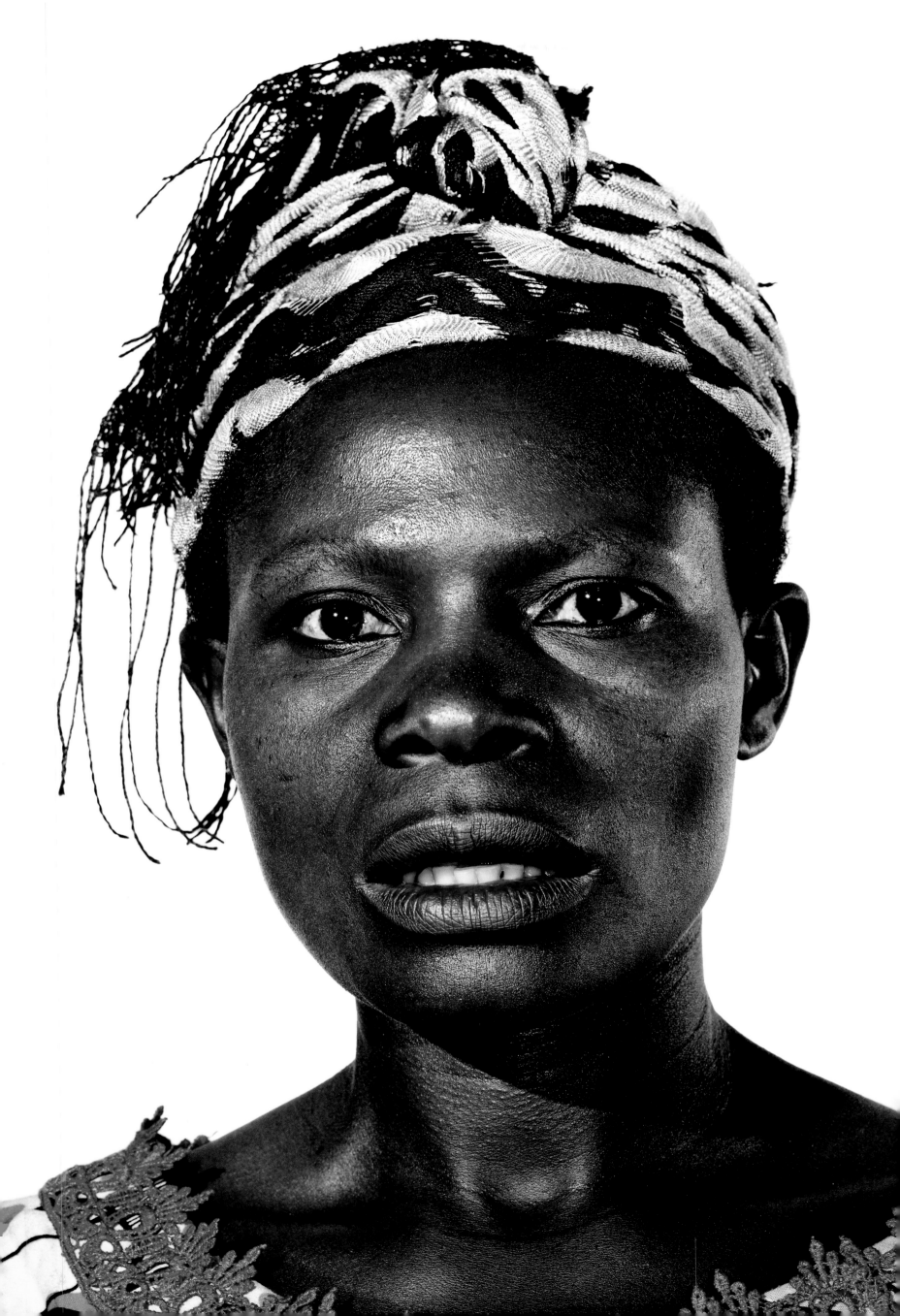

My name is Honorata

I am 58, married, and a mother of seven. I studied and got a secondary school diploma. First, I became a teacher, and then a headmistress. I speak three languages and was a very respected woman in my community.

But that was a long time ago. To survive, I had to do some other activities. I sold some small items at the mines, so that I could satisfy some basic needs.

One weekend in 2001, while I was at the mine trying to sell what I had, rebels came and attacked us, and 10 of us women were taken into the forest. And then we came to a village, the one village in the forest. When we reached that village, they said that we had to become their meal. When we heard this, we thought that as we had made a very long trip and were hungry, they would give us food. But unfortunately, it was us who were to be food for them.

They said, "Before eating, we are going to give you some caress." But it was not the kind of tenderness that you're thinking of. They started beating us. I was beaten seriously. I don't have my teeth; they were knocked out. I even have scars on my face. All this was because of the injuries that I suffered from being beaten by them. The day I was captured, they cut my wedding ring off of my finger instead of just taking it off. They told me, you are no longer one man's wife. You are every man's wife from now on.

We were raped by so many men. When you thought you could get accustomed to one man, suddenly at night they changed. You would go to another village and find that you have new partners. In the beginning, I counted the number of rapists but when I reached 20, I said that I would not continue counting; it was enough. During that time, we cooked for them, carried their ammunition and water, and cleaned for them. We were their slaves in every way.

One day, they came to me and told me that I was appointed as "the Queen" for that day. I thought that I would be spared from being raped that day. Little did I know it was a very different story—not at all related to what others might think of when they think of a queen. Instead, they took me to the bush, and tied my hands and feet to a cross-like structure made out of trees. I was tied upside down so that my legs were spread. That's when men started

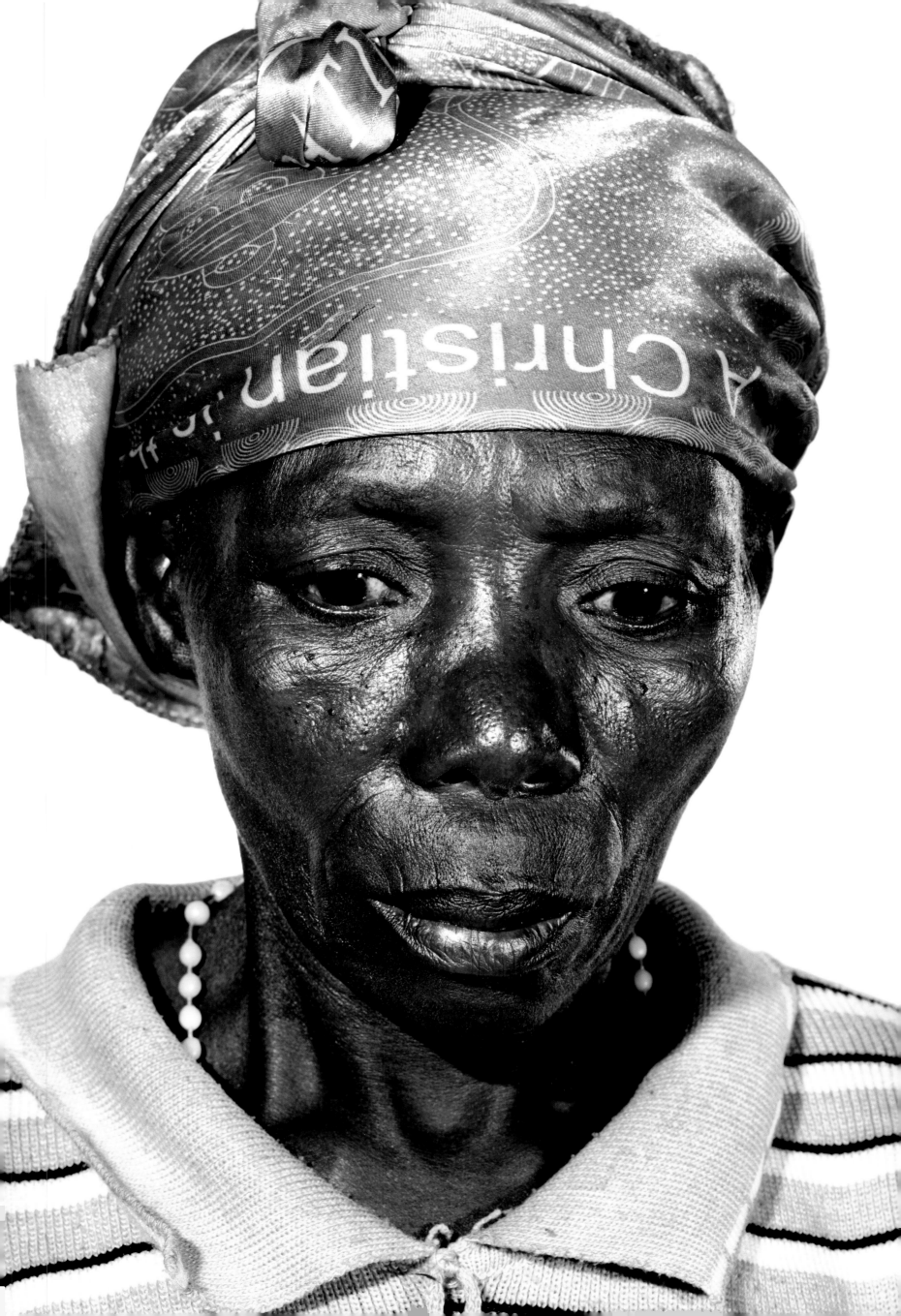

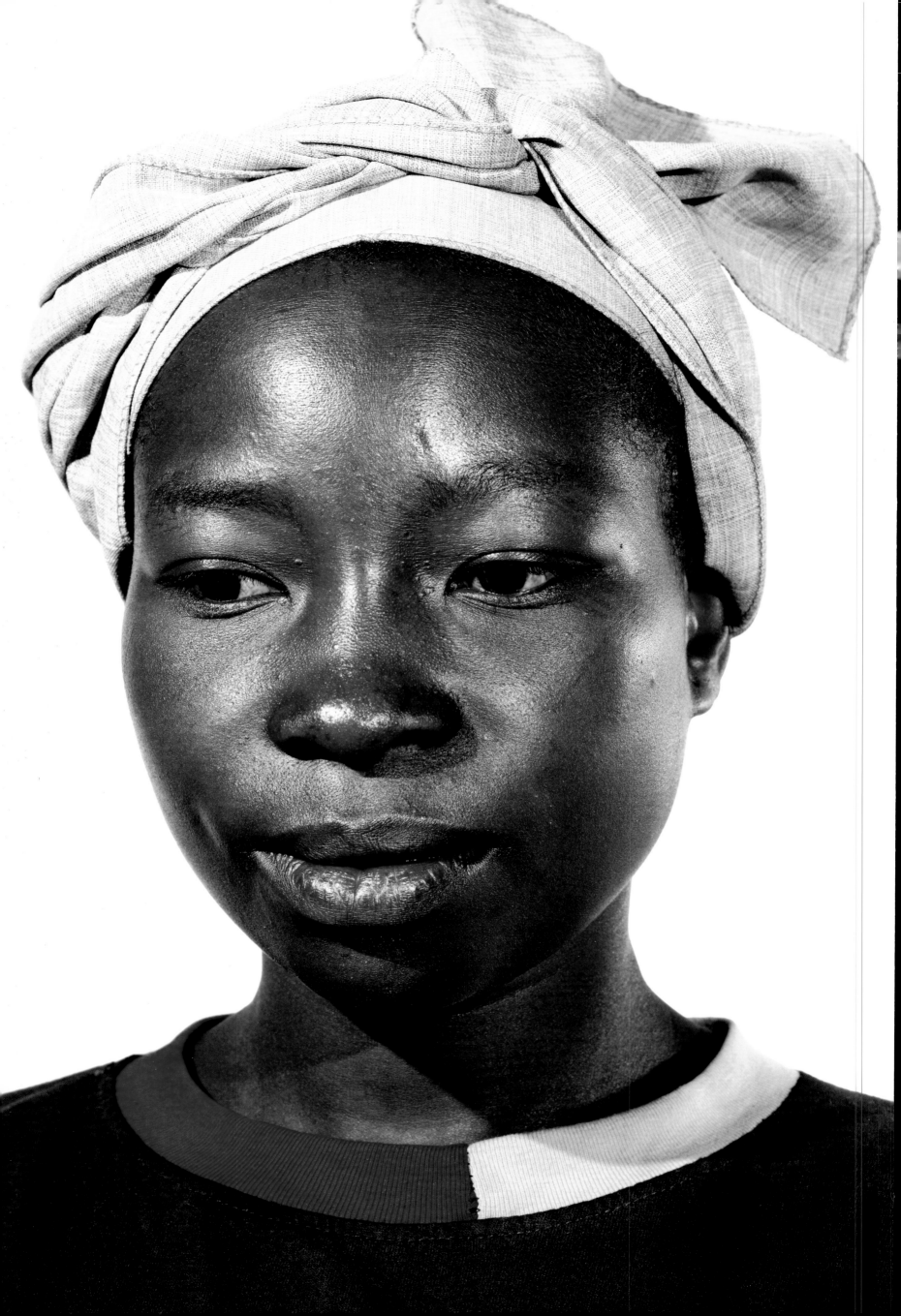

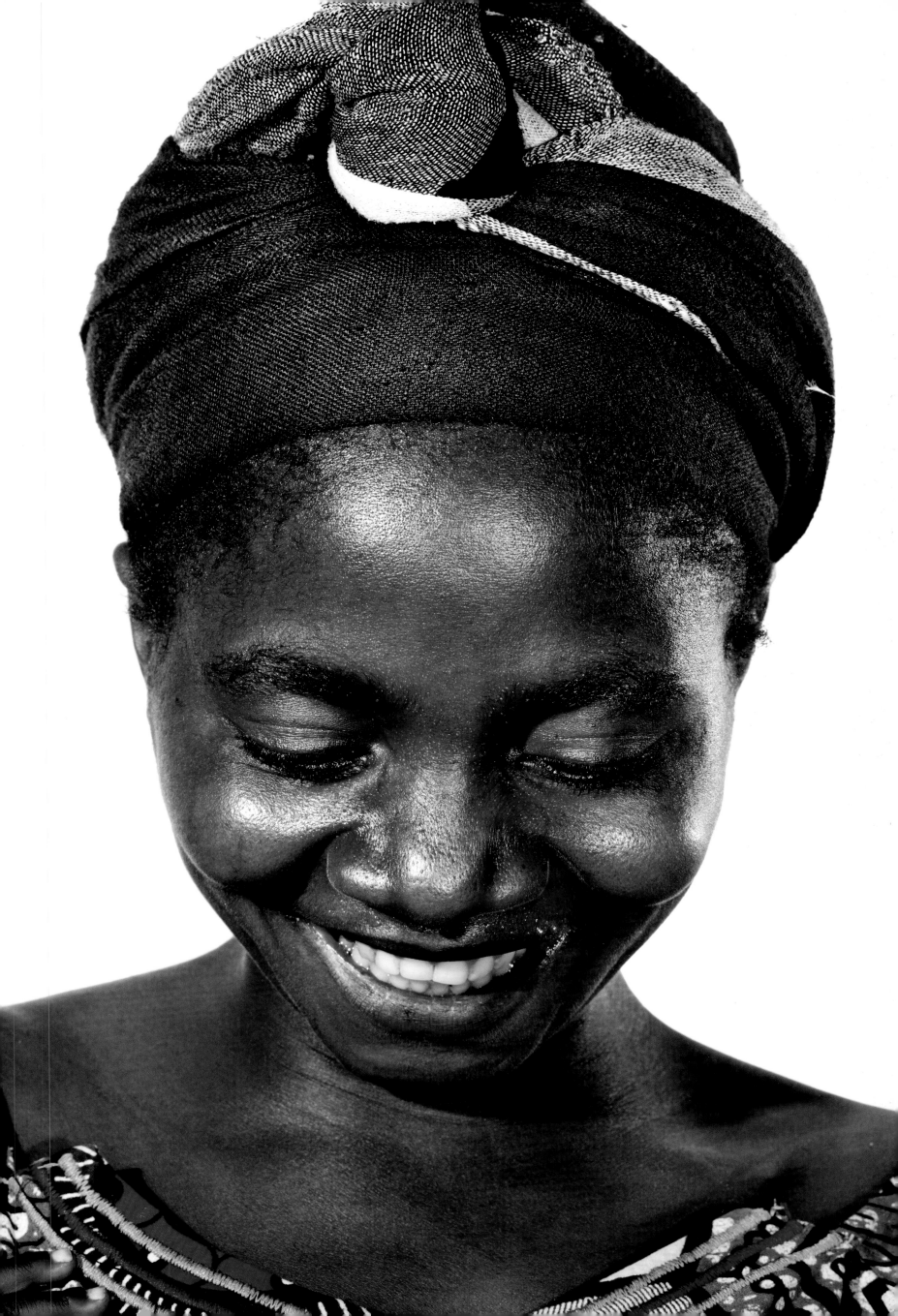

Afghanistan

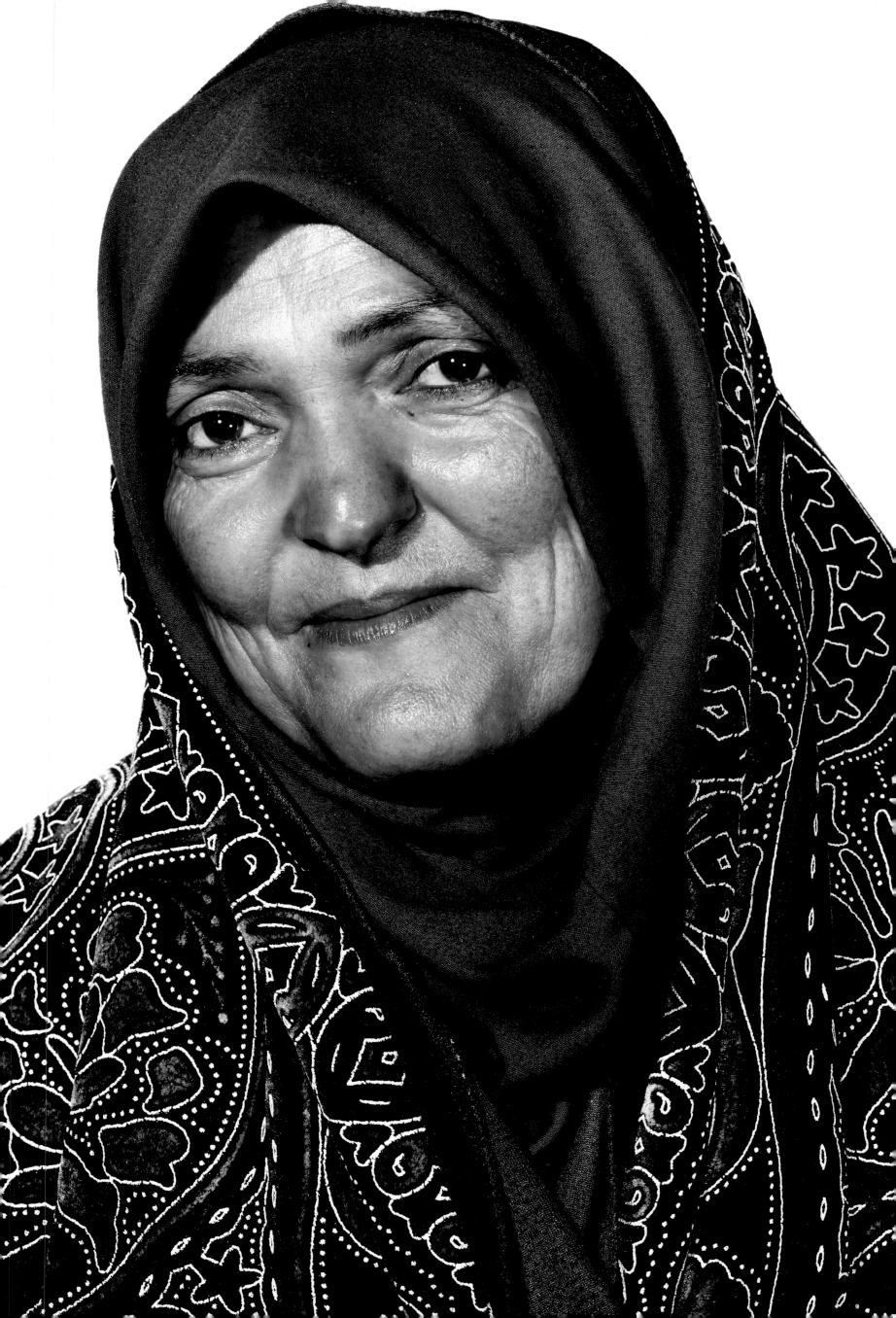

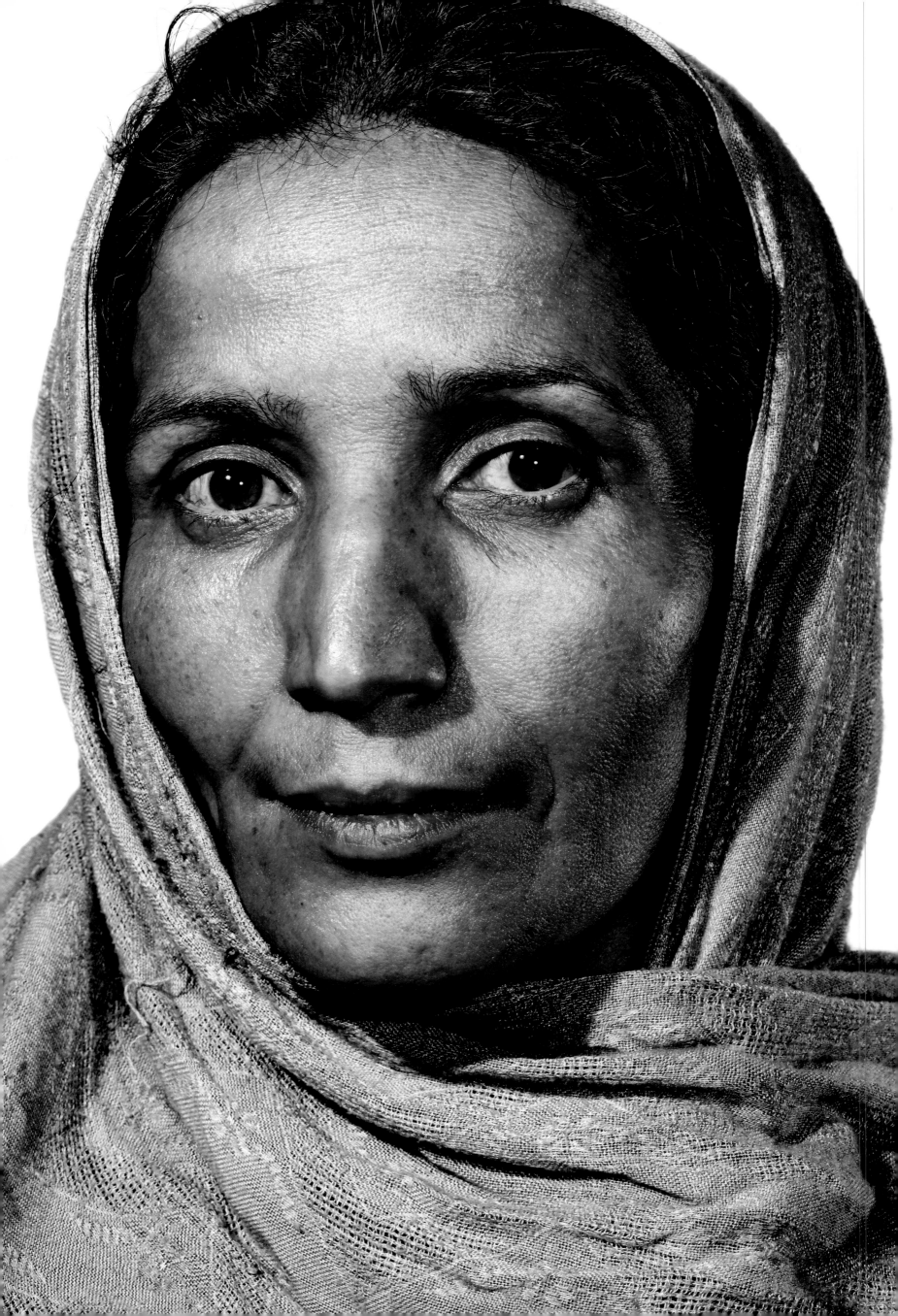

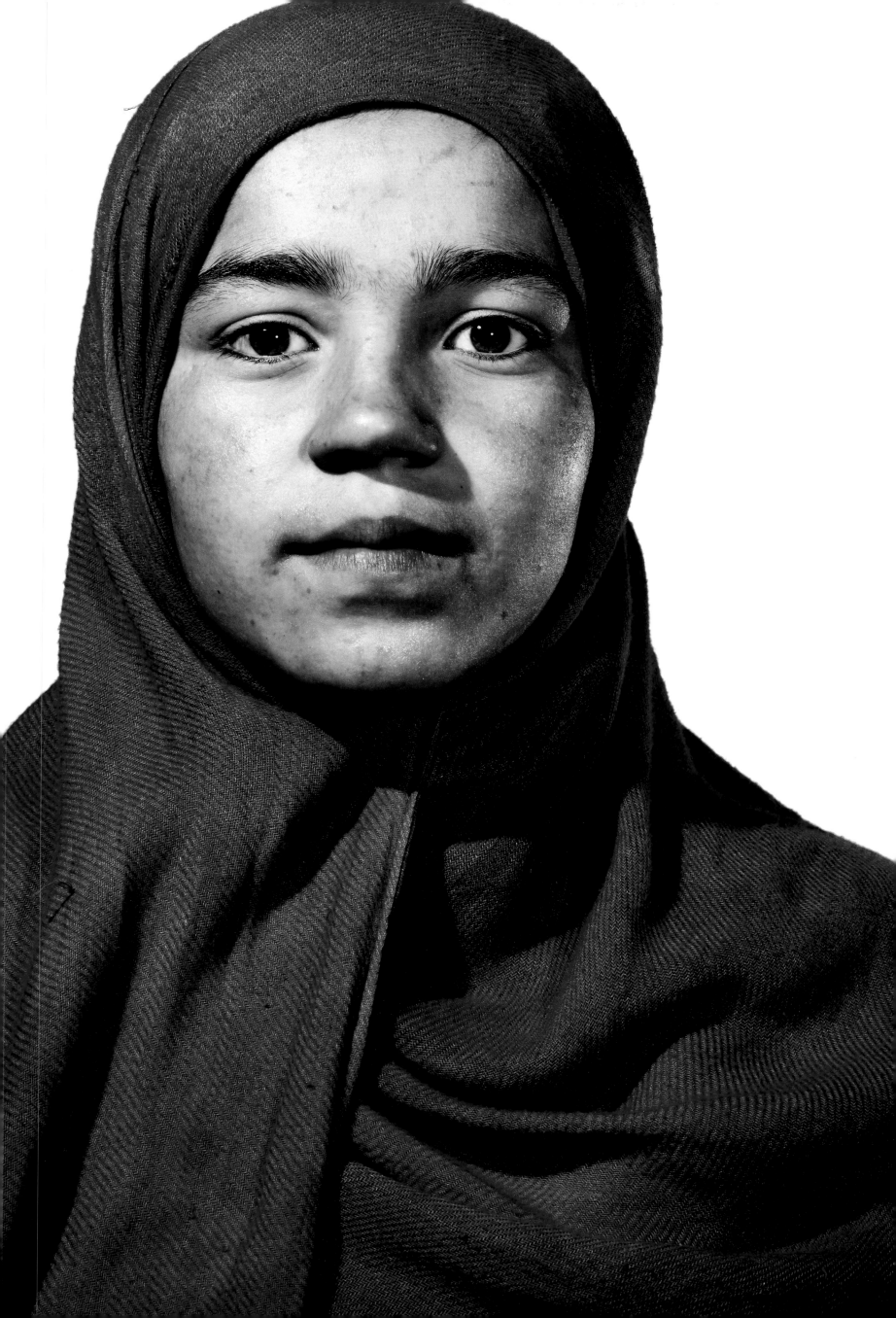

My name is Zarghuna

I am 38 years old. There was no happiness in my childhood. When I was six years old, my brother lost a dog-fighting match and started fighting with my cousin which led to my cousin's death. To solve the dispute between the two families, the local council decided that my family was to give a girl child to my uncle's family in marriage. I was only six years old at the time and was playing with friends when my father suddenly came, hugged me, and took me away from the girls I was playing with to where all the men had decided my future in my absence. My father brought me to my uncle and asked him, "This is what you want? Take her. Don't bring her back to us. We finish our dispute here." My uncle, who was now my father-in-law, put me on his back like I was a sack of rice and took me to his house. He left me in the yard with my mother-in-law, who was washing the clothes, and he said to her: "Take her with you. This is your daughter-in-law." I wanted to hide when I saw the anger on my uncle's face, but there was nowhere to hide. My uncle came to me with short knife and said: "If you escape from the house, this is your future. I will kill you with this knife."

My uncle was a very bad man and he would always punish me and say: "Look at your father. He gave you away." I didn't know at the time what that meant. I cried so much and asked so often, "Why has no one from my parents' house come to see me? Why am I not with them?" That's when my husband to be, then only nine years old, decided to take me to visit my parents. He said, "We'll wait until my father takes his nap, and then I will take you to see your family, but only for half an hour. We'll come back so quickly that my father won't know that we left." As we were trying to be quiet, we didn't check to see whether my father-in-law was sleeping. He had gone to the mosque instead and we did not know this. We wanted so much to escape from the house, together, hand-in-hand. And suddenly, just as we were about to leave the house, my uncle returned and saw us. He beat us so much. First his son and then me. I cried so much as he was beating me and swore to him and to God that I would never go back to see my family.

Time passed and life resumed but I was never able to be part of anything in the community. There were many parties—wedding parties, engagement parties, parties of all kinds—but my father-in-law never allowed me to attend these. I would hear the neighborhood gossiping about how I was traded and given to this family. I grew kind of ashamed. I wondered, "Why did all this happen to me? Why did they give me away to this family? Only to resolve a conflict?" These questions remain.

When I was 15, it was time to consummate the marriage. We had a small celebration but my family didn't show up. I liked my husband. I grew up with him and he was always kind

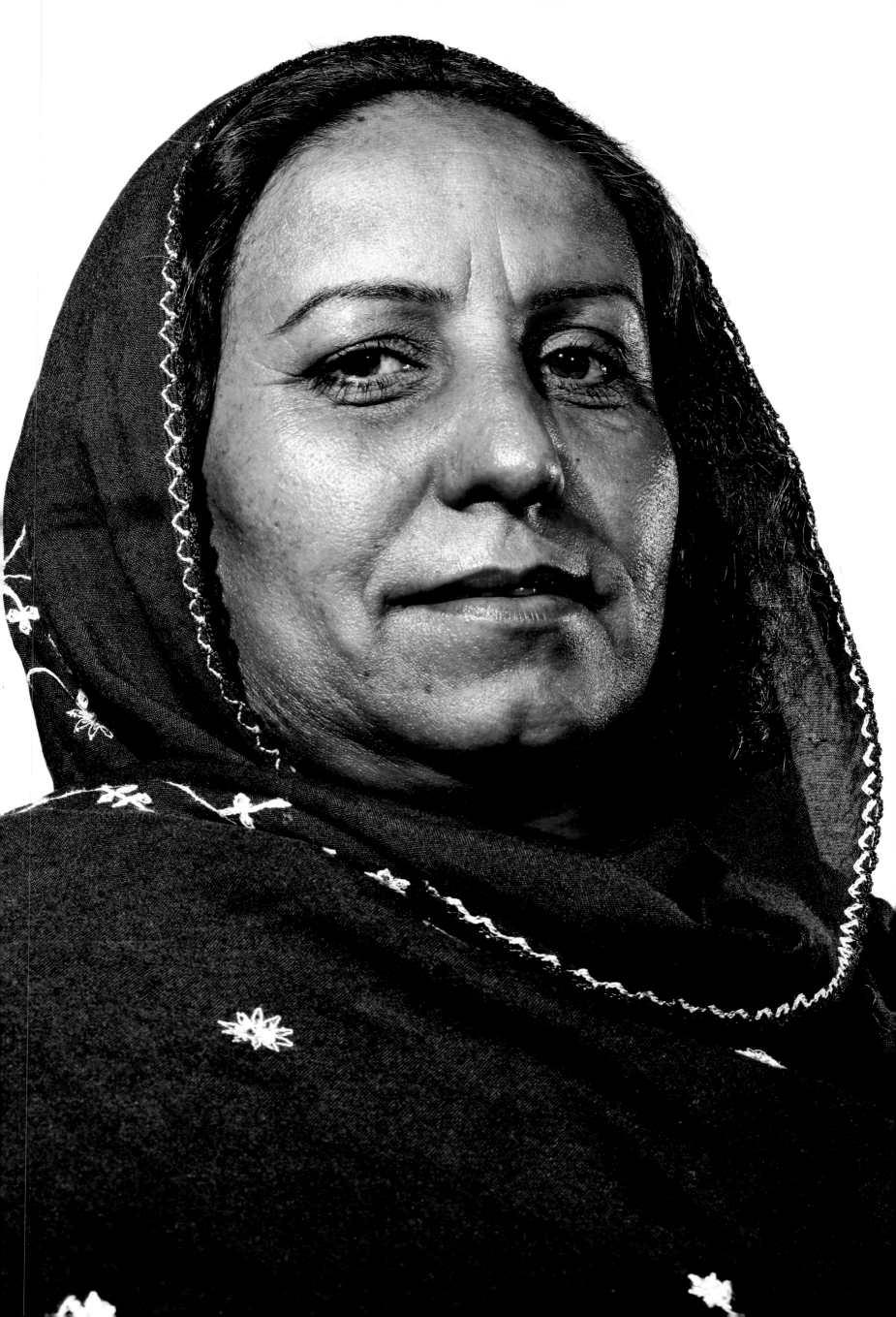

to me. I got pregnant shortly after my marriage and I had a baby girl. My husband, then 18 years old, had to join the army. He was to be stationed at Kandahar, where my parents lived. I begged him to ask for another location, but he told me, "Do not worry because now we are married, we have our baby girl, and all the anger will be gone from your parents' side."

He was due to come home on a scheduled break six months after his deployment. We were waiting for him to arrive when someone came on my parents' behalf and gave me my father's message: "Now you are completely free. Escape from this house and don't accept any marriage with your brother-in-laws. Now you are just free. Come back to us." And I understood. They had killed my husband. They thought that if they killed my husband, then I would be free and I was at an age to decide whether to stay with my daughter or go to my family.

But I hated my family. I hated the decision they made during my childhood. I didn't understand; I didn't have a choice. I didn't have any voice. So I sent the messenger back to my father with a message of my own: "I will never forgive you. If I lost every one of you, I still wouldn't forgive you. This is my final decision." So I stayed with my in-laws.

My mother-in-law was kind to me. But my uncle was a bad man, a very bad man, and was always punishing me. When he became infected with tuberculosis, he had to lie on his bed for years. He used to throw that bucket he used to urinate at me when he got angry. I felt I had no one to help me out, so I decided to commit suicide. I tried it twice and I failed twice. Once, I ate the medication used to kill the insects in our house. But it was so sour and bitter that I couldn't eat a lot of it. I put it inside a tomato and ate the tomato. After a few hours, my health got worse and worse. I heard my mother-in-law crying and asking my father-in-law to take me to the hospital. I heard my father-in-law say, "Let her die. We can send her to her parents and say, 'Take that. Your dead girl." My mother-in-law took me to the hospital and I survived. I wished to die but I couldn't kill myself. This is how my life continued.

When my father-in-law passed away, I started making hats and selling them outside my house. One day, as I was selling the hats in the street, a car-full of Talibans passed by. When they saw that I was wearing open shoes, they stopped and got out of the car. I couldn't wear closed shoes because my feet were swollen so I begged them to please leave me be and not beat me this time and I promised to wear shoes not sandals next time. They didn't listen to my pleas and started whipping me. After two lashes, I took the man's hand, took the lash from him and I threw it into the river. And I said to him, "Look, I asked you to leave me alone today and tomorrow I will wear shoes but you did not listen." The commander who was sitting in the car came out and asked what's going on. I told the commander, "Shame on your Pashtun men. I am a Pashtun and you are beating your people. Is that the way? I threw the lash into

the river." The commander told his soldier to go to the river and get the lash. He laughed at him for being stopped by a woman and thought of it as enough of a punishment. They left me alone. I don't know what got into me. It wasn't the pain of the beating that pushed me to stop the Taliban; it was the humiliation of being beating in public that drove me to use all my energy to put a stop to it.

I prayed every night for the Taliban to leave our country so I could see freedom in my homeland. Then came the day when all the streets were empty. No one was on the street and I was so scared and very early in the morning I woke my mother-in-law and said, "Come and see, outside, there is no one outside walking on the street. Something must have happened." When I heard that the Taliban were gone, I went to the kitchen, and I made halva and distributed it to all the people to thank God that we are now free from the Taliban.

After this, I went to the hospital for my depression. The doctor told me, "You don't need any medication. When you remember your past, it hurts you. So you need somewhere to go and sit with women, with different kinds of women—with lucky women and unlucky women, with poor women and rich women—so you can see how they are dealing with their problems and how they are dealing with the challenges that they face."

One of my friends told me about Women for Women International and how it provided training for women. When I joined, I found myself in a group of 25 women. That's when I learned that I wasn't alone in my suffering. There are other women, who have the same pain and the same hardships. To realize that was amazing. I went to the organization for a year until I graduated. After that I succeeded in finding a job in embroidery and handicraft. And I was always thinking about how I could build my own business. Eventually I decided to take a micro-loan of $500. From there I started selling my embroidered products and my business grew quickly. I am so proud to be able to tell you that I have $30,000 in the bank. And just a month ago, I was able to purchase machinery for $18,000 to improve my business. One day I know I will have a huge business in Afghanistan. I only wish to see peace in my country and expand my business more and more. For now, I am so happy that I am providing employment to 120 women, women who once suffered a lot. It's not only women that I hire. I also have men as employees and helping us with the sales.

I am always talking with the women. I wanted to share all my experiences and I tell them to be strong, as I became strong. I explain to them how I transformed from victim to active citizen. "So you have it. This is a lesson learned for each of you. You have to take that step to move forward." And as for my daughter—this year she is graduating from high school and I have a dream to see her in a university. On her graduation day from university, I will be relaxed.

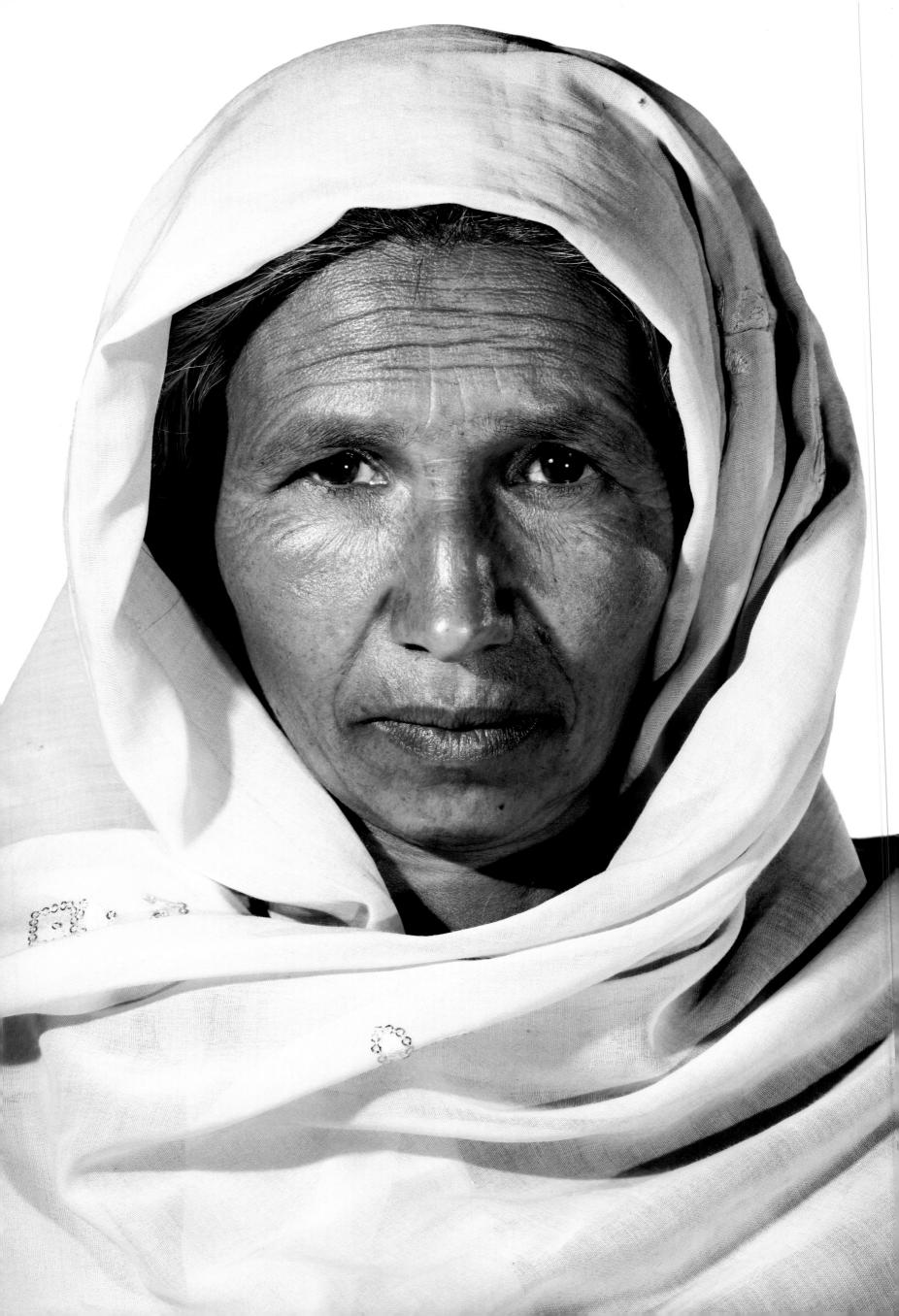

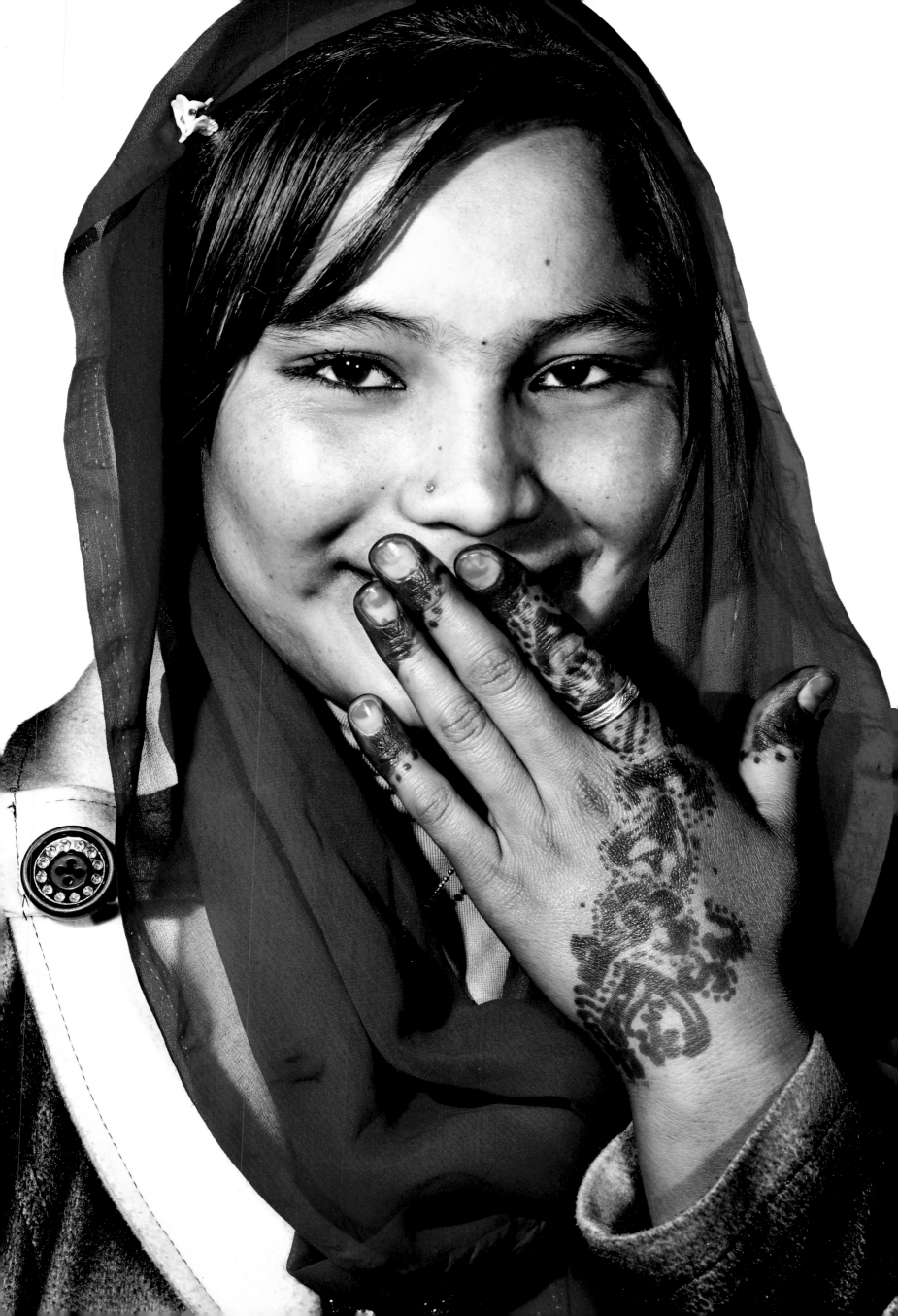

My name is Pari Gul

I am 39 years old. I am originally from Guhr province and my father was one of the famous and wealthy people in this province. He had nine daughters and five boys. My childhood was the most beautiful time in my life. When my mind takes me back to my childhood, I feel like I was such a lucky person. I lived in a big house as part of a big family. My father was the owner of a huge plot of land. We had a cook and cleaners, and so many cows and sheep and workers to look after them. And we had farmers that we paid to work on our land.

Russians entered our country and the situation deteriorated when I was eight years old. My father joined the Mujahideens along with my brothers to defend our country. It was a very dangerous time for us to remain in the village because the Russian troops were there and they killed people. To save my life, my father arranged for me to be married. I was only 11 years old at the time and my husband was a teacher at Kabul University. I had been allowed to continue my studies until seventh grade while I was in Guhr province. But after I moved to Kabul I stopped going to school due to pressure from women in my husband's family.

Ten days after I got married, our house was invaded by Russian troops and I heard that two of my brothers were killed in that invasion. One of them had been a groom just a week before he was killed. I never saw my parents after that. When I remember that day, I cry. I could not go to the village for my brothers' funeral because it was not safe. My father heard that two of his sons were killed and he died shortly after. And again I could not go to his funeral. Never would I ever see my father again.

As for my marriage, in the beginning, I was happy with my husband because he was the person who taught me how to cook and how to clean the house; I learned everything from him. And he was so open to me. So it was a good time. But, all this time, I was always thinking of my family, wondering where they were and whether they were alive. So one day, 13 years after I left my village, I decided to write a letter and ask someone to take it to my village. Months passed before a visitor knocked on my door. I saw a man with a turban standing there and I was scared wondering who he might be. That's when my little boy went to find out who he was. It was my brother. We were children when we separated and when I finally recognized him, I hugged him and cried. It still remember this moment with fondness.

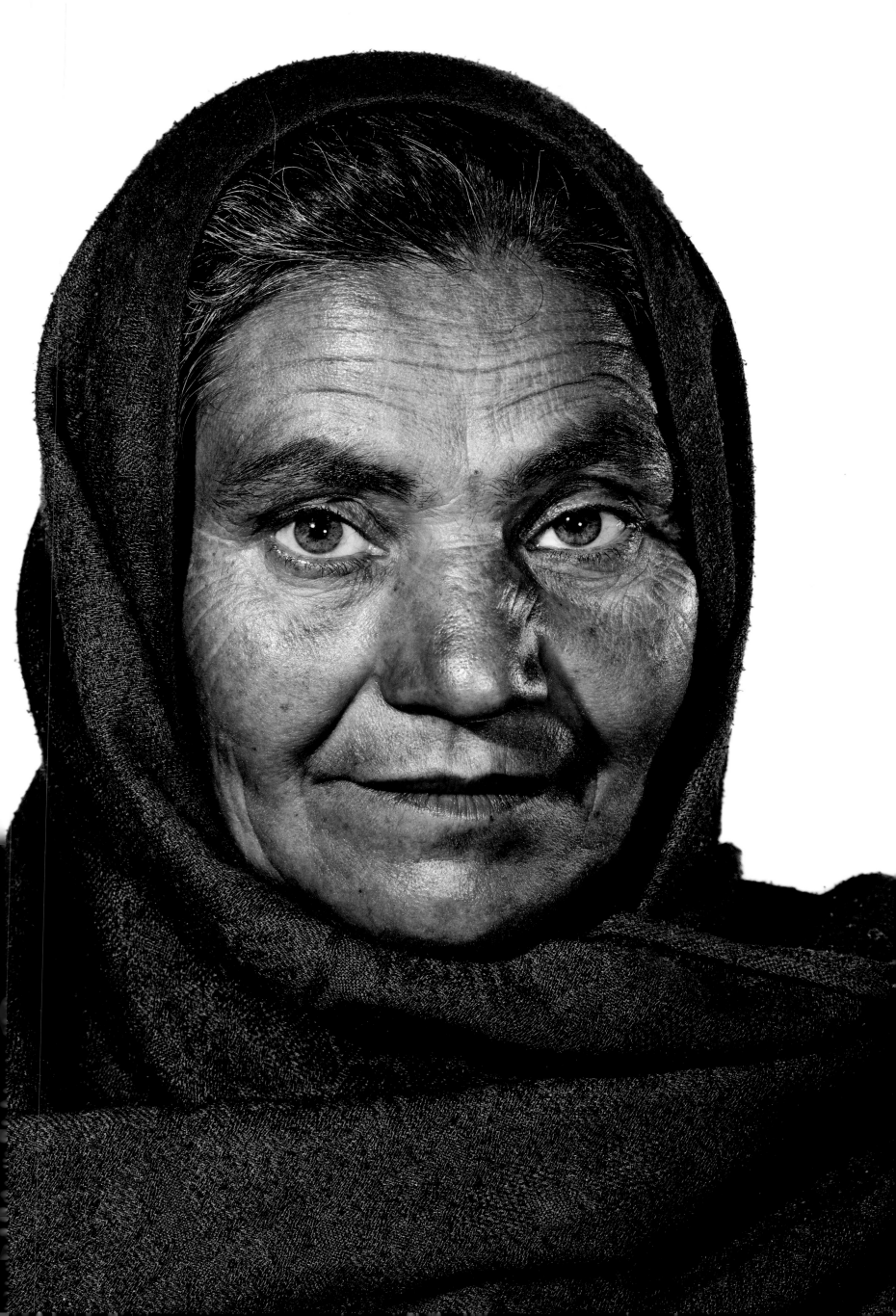

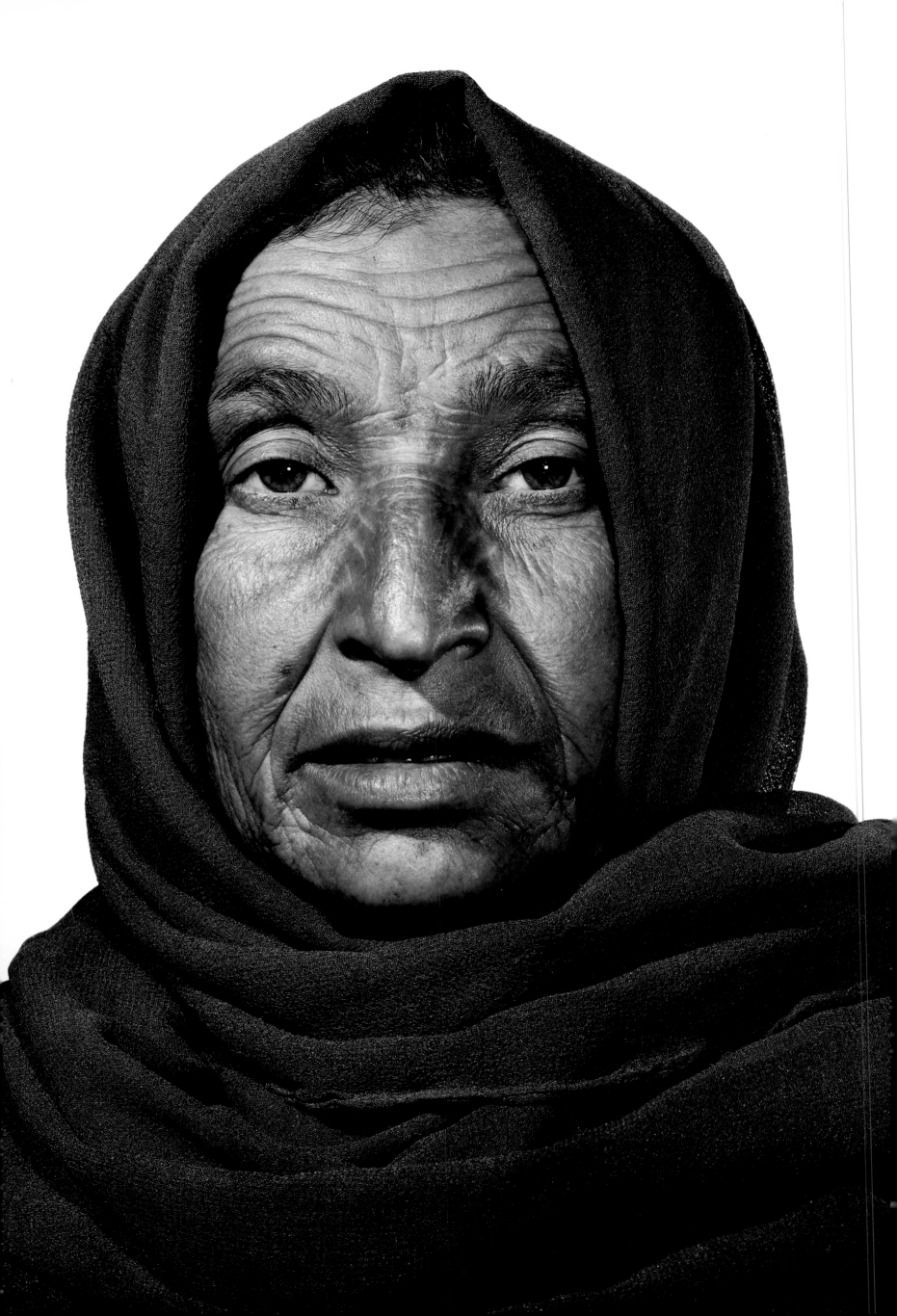

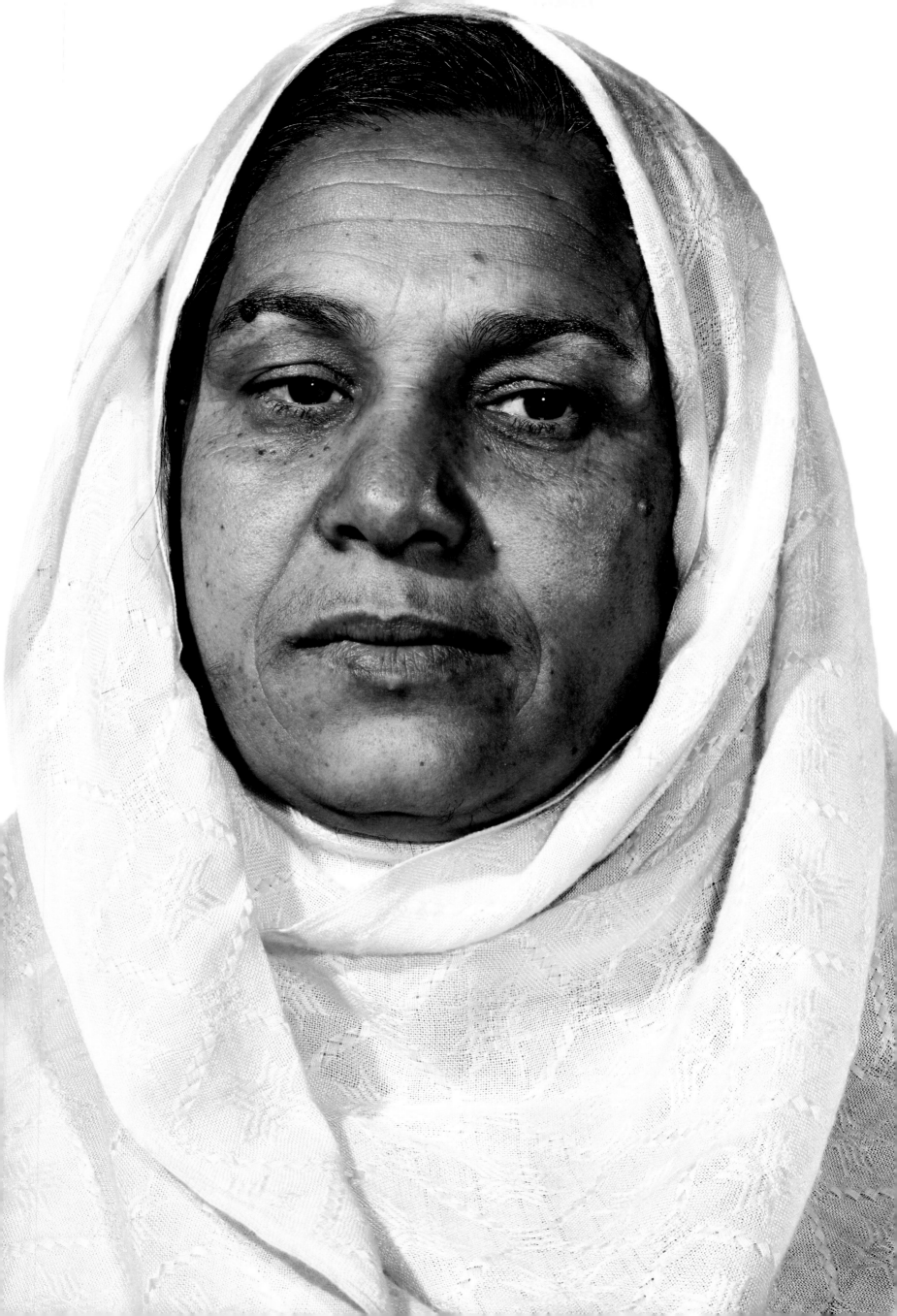

I am always working on losing weight. For now, I am focusing on my studies. It is my dream to get a master's degree and help others to be educated.

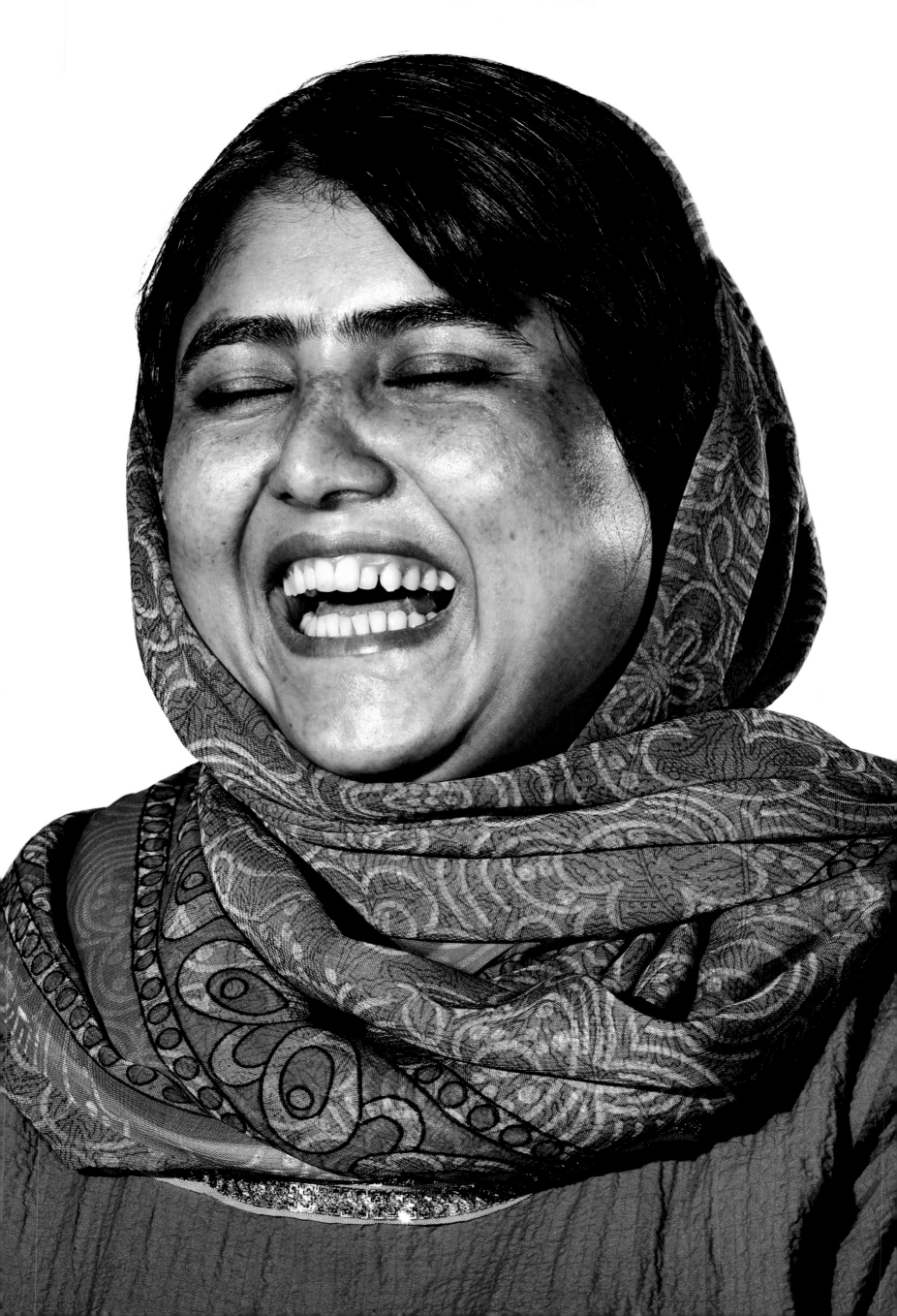

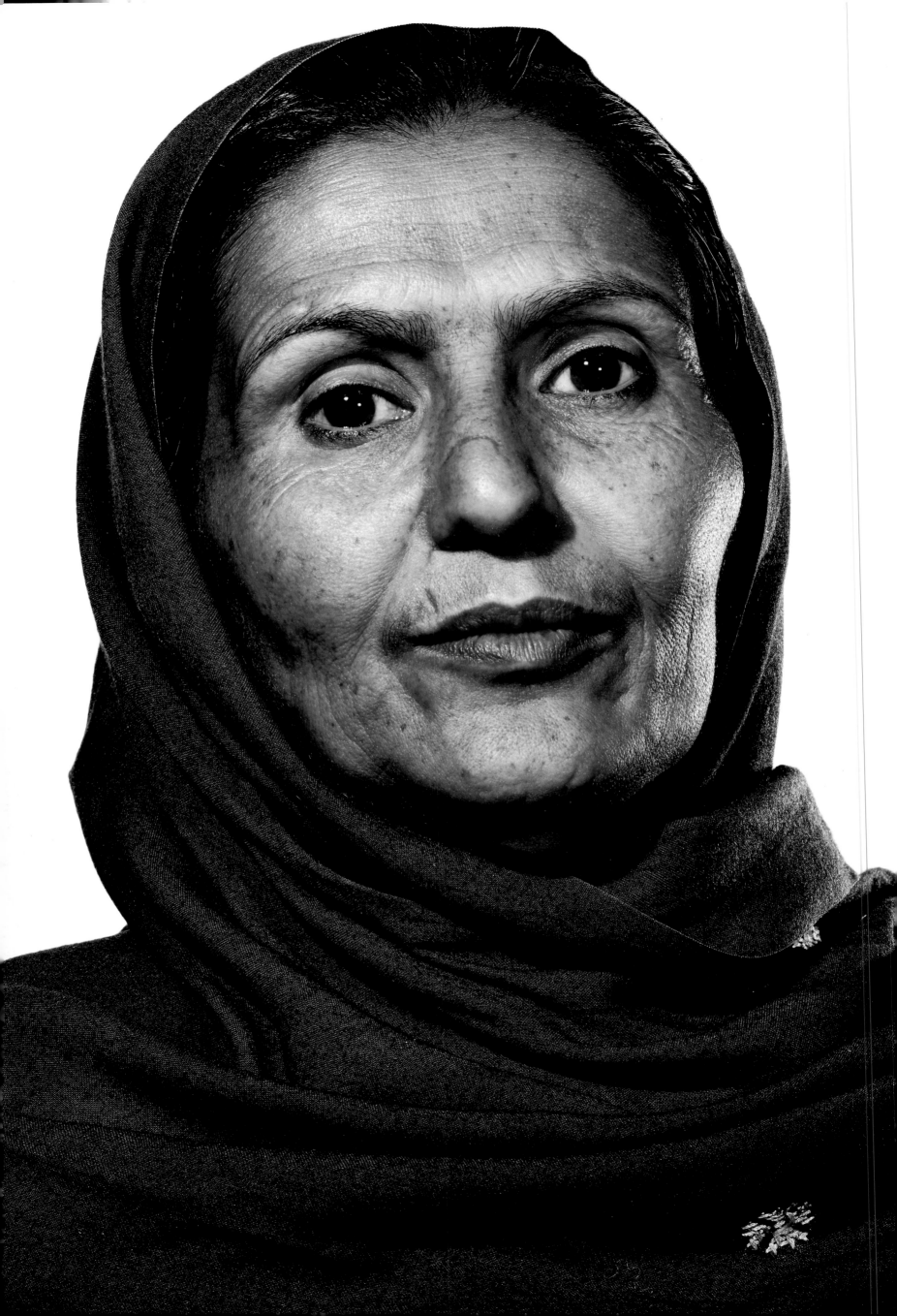

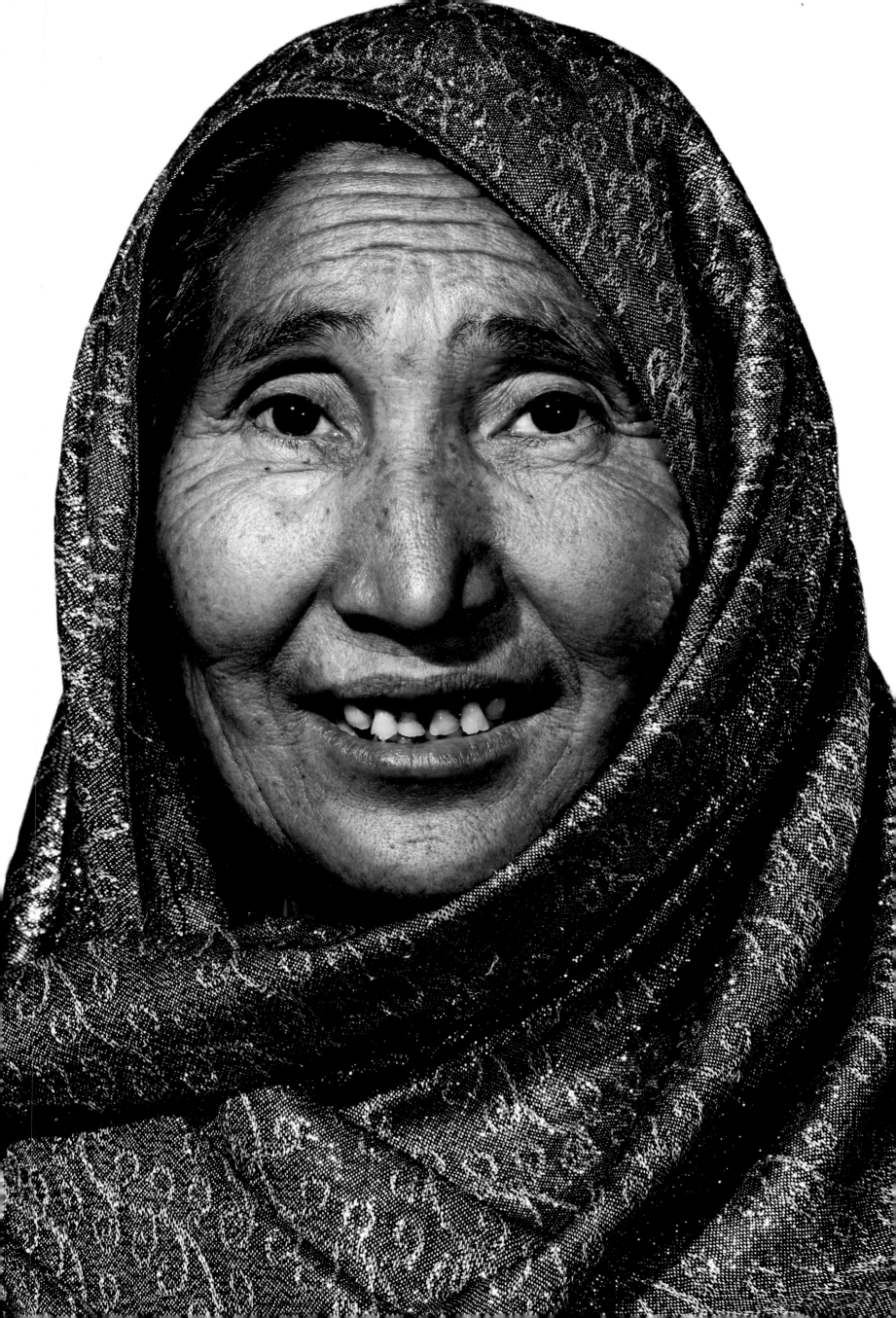

War means the absence of peace, and fighting everywhere. I was among those who took up a gun and fought against the Taliban for a year. I knew that I risked my life but it was my spirit that drove me to fight against the Taliban and to remove them from my country.

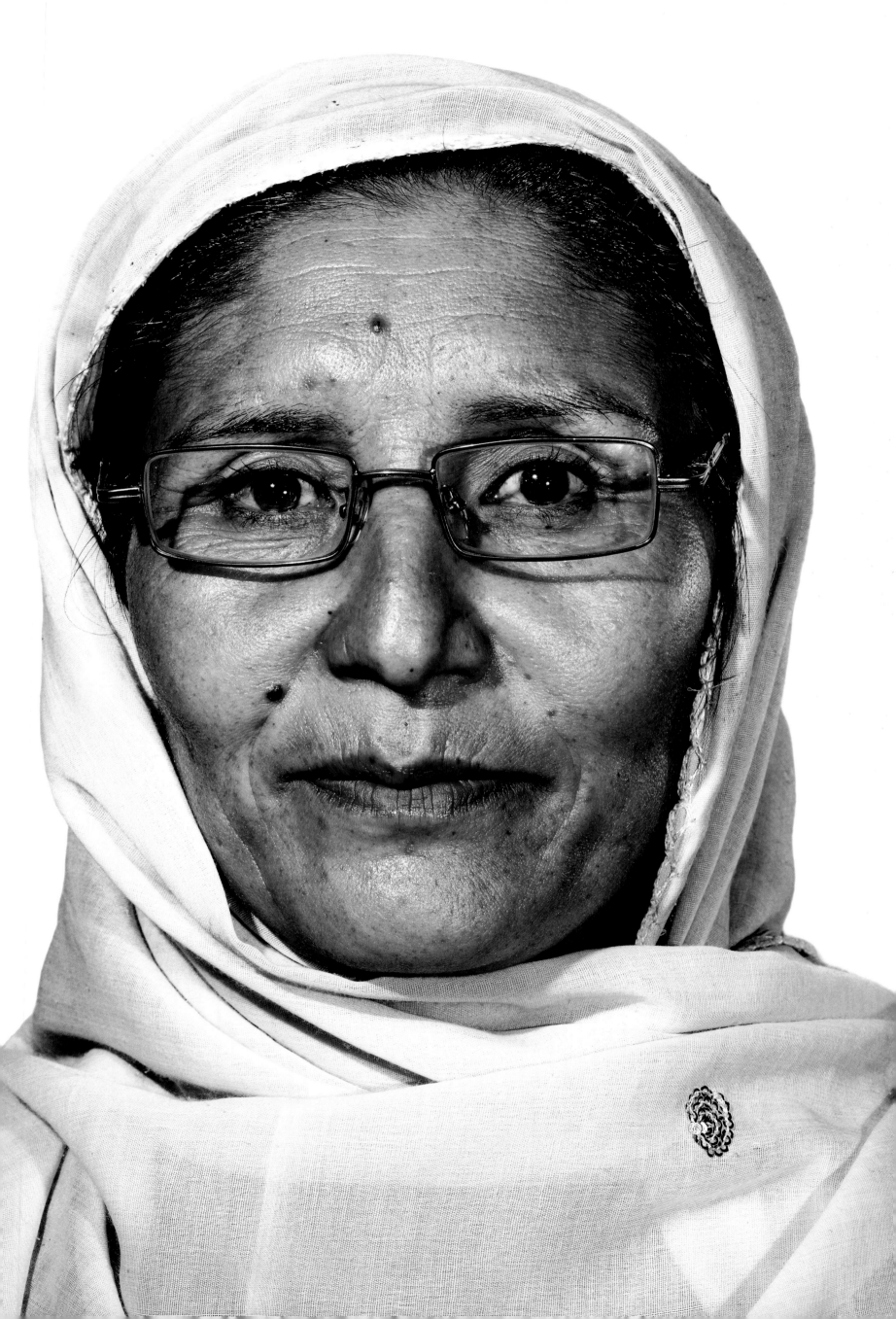

Rwanda

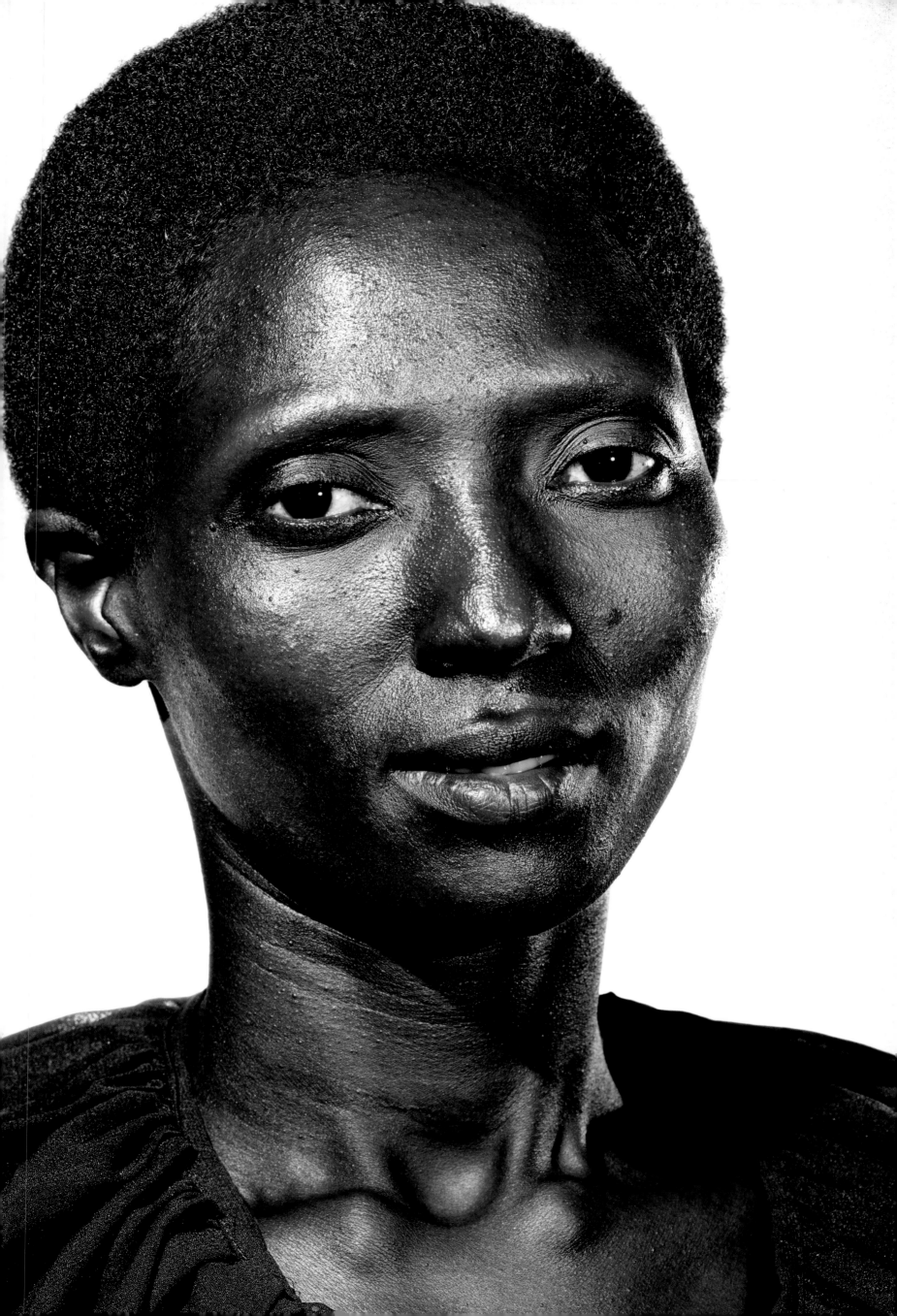

My name is Caritas

I'm 39 years old. I'm married and I have two children of my own, a son and a daughter. And I have adopted five more children, because of the genocides.

I was at school when the genocides happened. I had eight brothers. Seven of them died during the genocide. And my father too. Only my mother, one brother, and I survived.

After the genocide, I really didn't feel like doing much. After what I saw, I thought that my life had ended right there. Yes, I managed to survive, but at first I could not bring myself to like the country. But when I started to see once more people I was not expecting to see—when they started to return to me and reenter my life—I started to come around. And, like that, my life got another chance.

Seeing my brother helped turn things around. He had been hit by some bullets and I didn't think that he would survive. I had told myself that I would die alone. But someone helped him and he returned to me. I was very happy and now he is alive.

For a while too, I thought I would never see my mom again. I tried to find her but everyone kept telling me that she had died. Again, I felt like my life had stopped. I didn't get married and I didn't go back to school. But then, one day, after a long search, I managed to find her. It was a miracle.

We were homeless for a while and life was very hard. I found some work and managed to save some money which I used to rent a small house, with just one room, and my mother and I lived there together.

It was during this time that I met my husband at a friend's home. This friend escaped the genocide, and I used to go there to hear his testimony, and my husband used to go there too. We met and got to know each other and started a relationship. His first wife was killed in the genocide. He was my first love. I loved this man because he used to tell me how he escaped the genocide and how he's now surviving and raising his children on his own. And I told you earlier, I love orphans. When I went to visit him at his home, I could see how he struggled with his children. I fell in love with his children and I agreed to take care of them. So we agreed that we should live together.

I had a dream of getting married officially, with a proper wedding, and when I told him that, he refused. And that was our first confrontation. He wanted me to move in to look after his children while he was out looking for a job so he could support them. "We'll see, maybe later," he said. When I said that I would not marry him without an official wedding, he told me, "I know that you love children. I think you should join me in raising these children and later you can ask God for the official wedding."

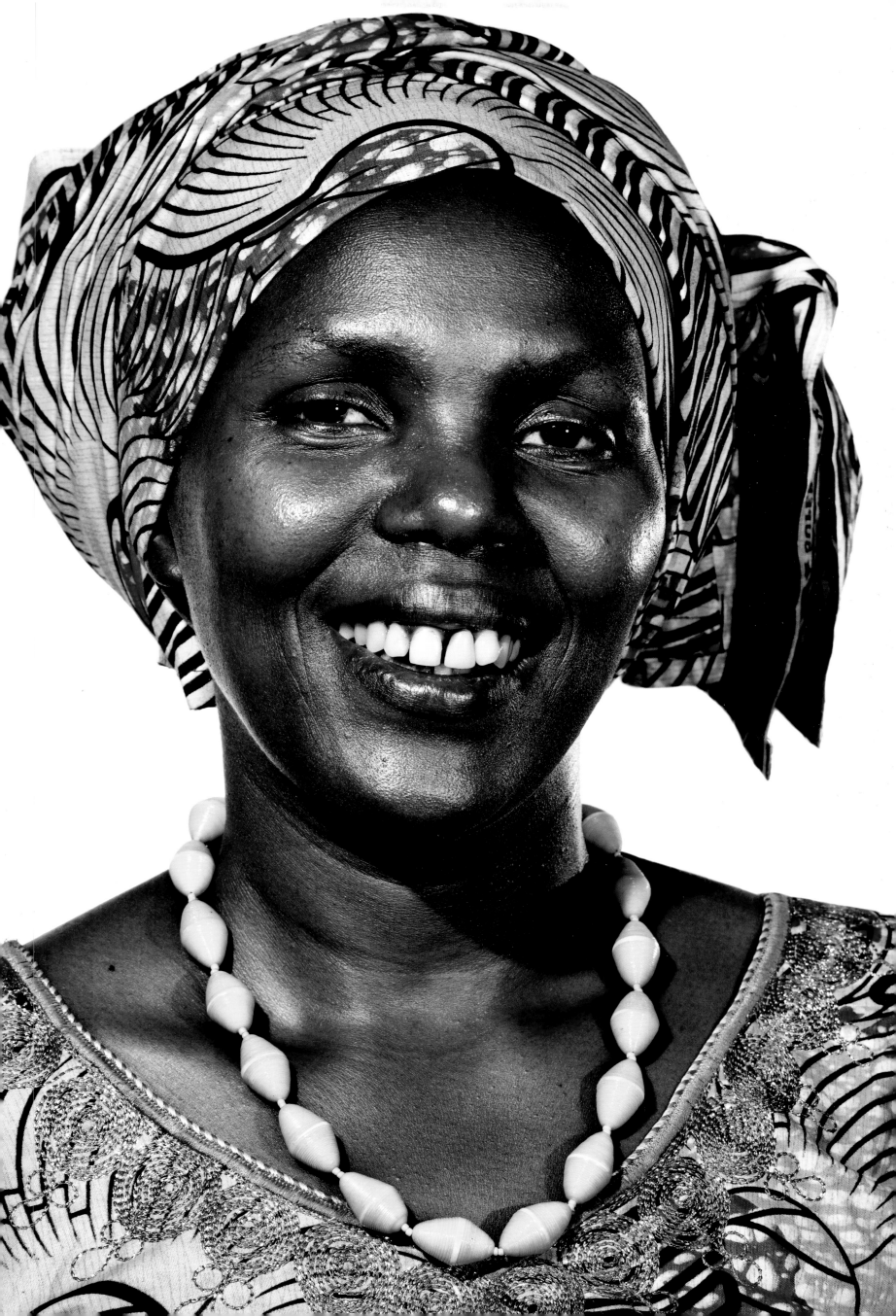

I went to his home because he asked me to, and I saw the children, who were very, very poor with no care. It was then that I decided to join him, to take care of those children. The marriage was really challenging. We had good times and bad—which is normal in marriage. The good thing was that I became a woman and I was respected by my society. I was called a woman, a wife of somebody. And I also bore children. I had a daughter, then twins, then a boy. But the twins died shortly after they were born. That hurt me a lot. They died. I could have had four children but now I have only two.

I once thought marriage would provide support to me as well, that it wasn't just me giving support to the man. But you discover in life that you don't always get what you expect; instead, you just get disappointed. So sometimes I am disappointed because my expectations are not met. When you live with somebody, you expect to sit together, to plan together. But my husband and I don't plan together. He does what he wants. I do what I want. Really, I feel bad when I say that. But something which I do appreciate is that he managed to give me an official wedding. In the end, I convinced him, and we had our official wedding. But still, planning together was a challenge for my marriage—until now.

In the past, my husband would sometimes beat me. He would knock me on the head in such a way that no one could even see that I had been beaten. So, I could not even report him to the police, because there was no evidence. And he wanted me to stay at home. He didn't want me to go out and meet other women that I could talk with.

So, to have more peace at home, I used to lock myself in the house and do all the chores. But later, a friend of mine heard about an NGO called Women for Women International and that it was enrolling. She went there to enroll for herself and helped me to get information. This was after I had just delivered my twins who died, so I couldn't go. My daughter went there and helped me to fill out the form. And, later, I escaped. I say that I escaped, because I left the house when I could be sure that my husband was not there, and he didn't know for a month that I went to the organization.

But eventually he found out, because he went on leave and stayed at home, but me, I had to leave, I had to go for training. And so I told him that I was going, even if he didn't want me to. Later, we had a session on women's rights. And when I came back from that session, I sat down with him and explained everything that I had learned and I told him, "From today on, if you beat me again, I am going to report you. Because, I now know my rights."

My husband's response was, "My wife, who has given me poison? Because this the first time I hear you speaking like this. I have told you that women are not good. When did you join them? They have taught you bad things now. You are starting to tell me bad stories."

He followed me one day and watched me as I entered the Women for Women office. He waited for me outside until I got out of the training. When I came out again, he told me that he had been following me.

I told him, "This is only for women. If you try to enter the Women for Women office, the guards are going to beat you." He responded, "Ahhh, woman, you are now who you are because God has given me a watch."

So, my husband started treating me like an independent woman because I now did what I felt was good for me. And after a few months we started learning beading skills. And me, because I loved it, I could bead for the whole day, while others would do it only for some hours. And I came to learn it very quickly. And I would tell my husband that now that we are learning skills, it would take us the full day. That way, he would not ask me again where I was. I stayed and learned with two groups—when one finished, I joined another group to keep learning. And after one month, we already started to see progress. And he started seeing me, wearing clothes which he did not buy for me, and good shoes which he did not provide for me, and he started giving me the opportunity to plan with him at home.

I discovered what beadwork could do because of a neighbor I had who was extremely poor. She had no support like me. But one day, I went to her home and found everything had changed, like she suddenly had a rich man to provide for her: good chairs, everything clean. I asked her how she managed to change her life. And she told me that it was because of the beads. There was an association of widows from the genocide supported by a woman who trained to make pins and found a market in Europe. So, this is how my neighbor managed to buy good chairs in her home, and her life was really very transformed. I asked her if I could join the association too and she told me as I was not a genocide widow, I could not. But, I always kept that desire to do the beadwork in my heart.

Because I knew of the importance of beads, I tried to convince my group at Women for Women that we should do beads, but most of the women could not understand the importance of doing beads. So I tried to explain it to them, sharing the story of my neighbor and how her life has been transformed because of the beads. Some understood and joined me. We were a total of 10 and that allowed us to start work. And this is how we started doing beads. And we learned it quickly. It really gave me something very positive. And I was able to make the money I needed to fix my teeth. During the genocide, I had some problem with my teeth. So, I went to see the doctor, asking him if I could fix my teeth. As you can see, I now have good teeth.

And my husband is no longer beating me. That is something which is very positive for me. And I was able to buy a piece of land and now I can buy food, clothes, and even some other things which I use in the house. And my house is very clean. I have very beautiful chairs. This is what I did. I managed to buy those chairs myself.

There are some things that my husband did which I have forgiven, but there are some which I haven't yet. We are still negotiating and seeing where we can agree. I'm trying to change his mind, but it is very, very hard work.

My life is very bright because I have learned a skill that will allow me to have some income and provide for all my needs. I'm sure that in the future I will have even more markets. I can even send my beads outside Rwanda to earn more money, so that I can construct my own house on the land that I bought and I can have my own home. And I hope to put my children in a good school, so that they can learn as I have been able to.

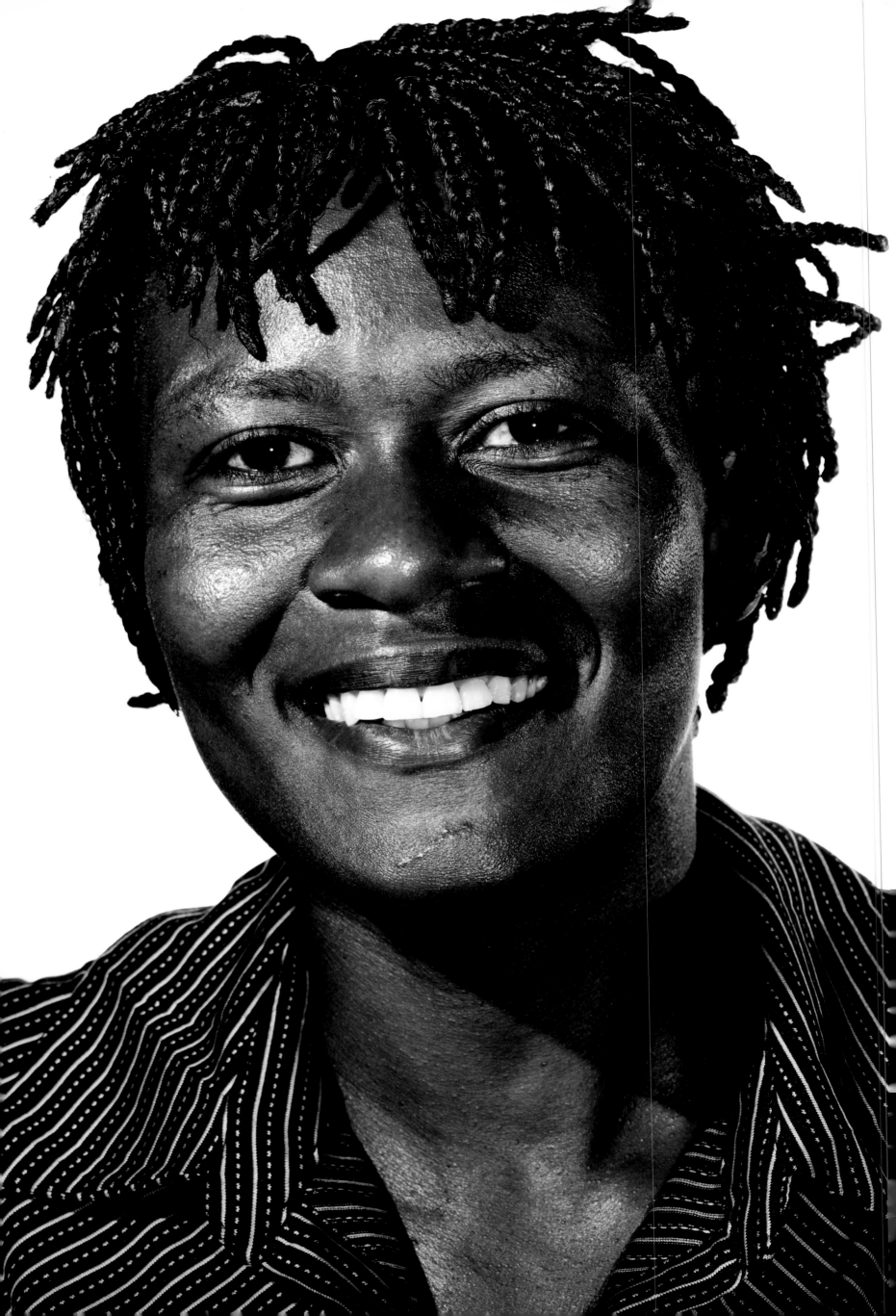

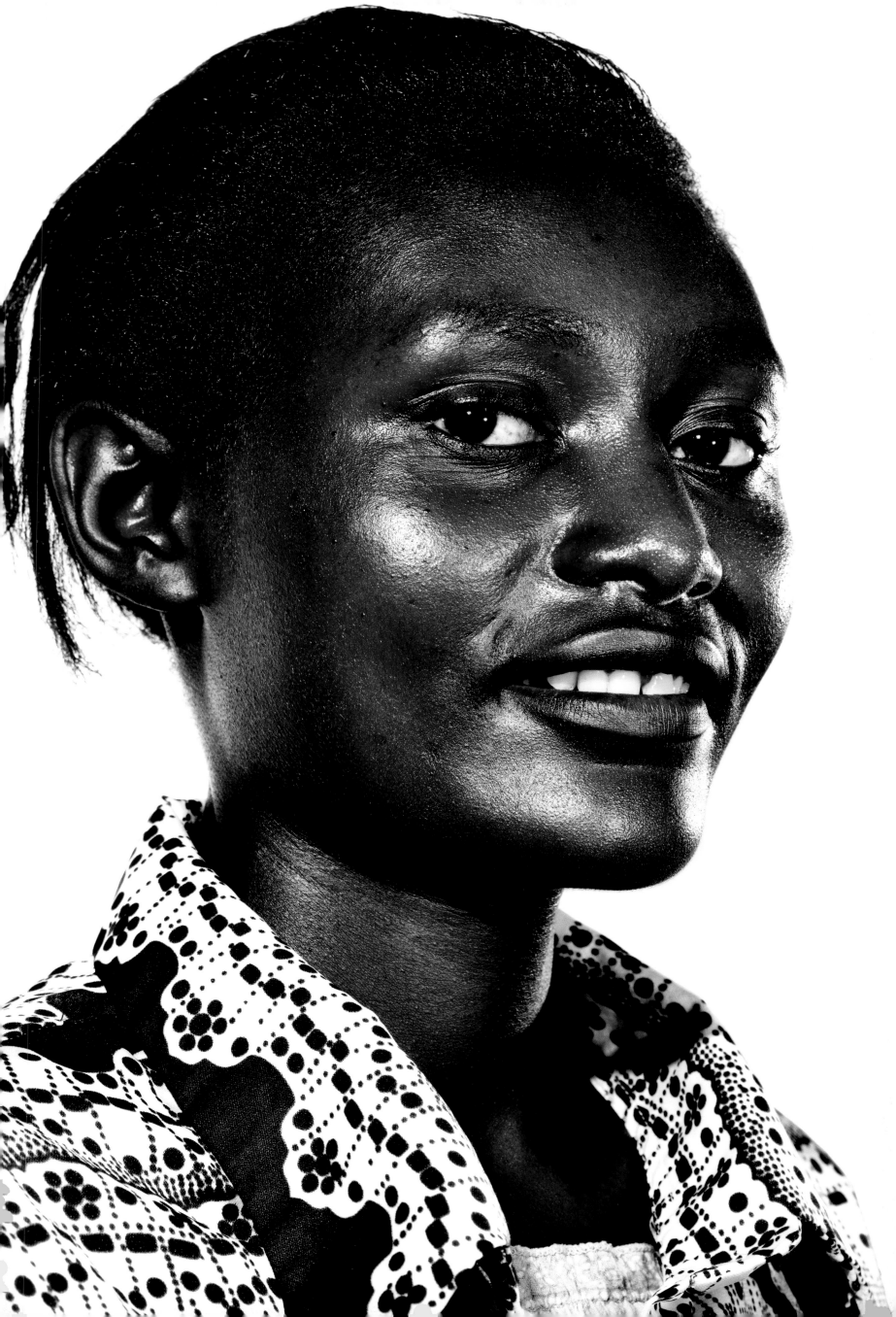

My name is Euphrasie

I'm married with five children—three girls and two boys. I'm 50 years old. I was the eighth child, out of ten in our family. Rwanda was where I was when the genocide began. I escaped during the genocide and I did not return to Rwanda until after it ended.

My parents really loved me very much. I went to school—six years at primary school and four years at secondary school. I had dreamed of becoming a teacher. But when I was 20, I got married, and after that I never went back to school again.

It was not my plan to get married, but one day I was walking to school and I passed by two men. One was a friend of the family so I greeted him. The man with him apparently asked him about me and shortly afterwards, excused himself and left the other guy. I didn't know he was coming to me. He asked me to join him on his walk and because he was a friend of a family friend, I agreed. I didn't know that I would end up locked up in a room where he forced himself on me, in this way forcing me to be his wife. Things never went back to normal after that day. I was so unhappy. I couldn't go to school and I became his wife.

After some months, I became pregnant and I gave birth to a child but she died. A few months later, I became pregnant again, and again, the child died. My son, who is here, is my third child. I was a housewife taking care of my children and my family. I didn't visit or talk to many people. And my relationship with my husband wasn't the best. I remember, sometimes, he would come home drunk and start beating me. He would even tell me that I was useless because I didn't contribute anything to our home. I tried to run some small businesses but as they did not go how I wanted, I stopped.

I used to live near the sector office and one day, I heard some women talking about a women's NGO that was going to teach them some skills. I was interested, so two weeks later, I went too, and registered to join the organization. I was really very happy meeting other women in my group because I wanted the chance to discuss and share experiences with other women. For me, it was like we were building each other. You can share your experiences with another woman, she can share her experiences with you, and you feel like you are not suffering alone and there is a way to get out of it. The training we received was very useful because we would use it to start our discussions.

Among the lessons taught, I was most impressed by the women's rights session because that helped me a lot to be more aware and see how I could have my rights respected at home.

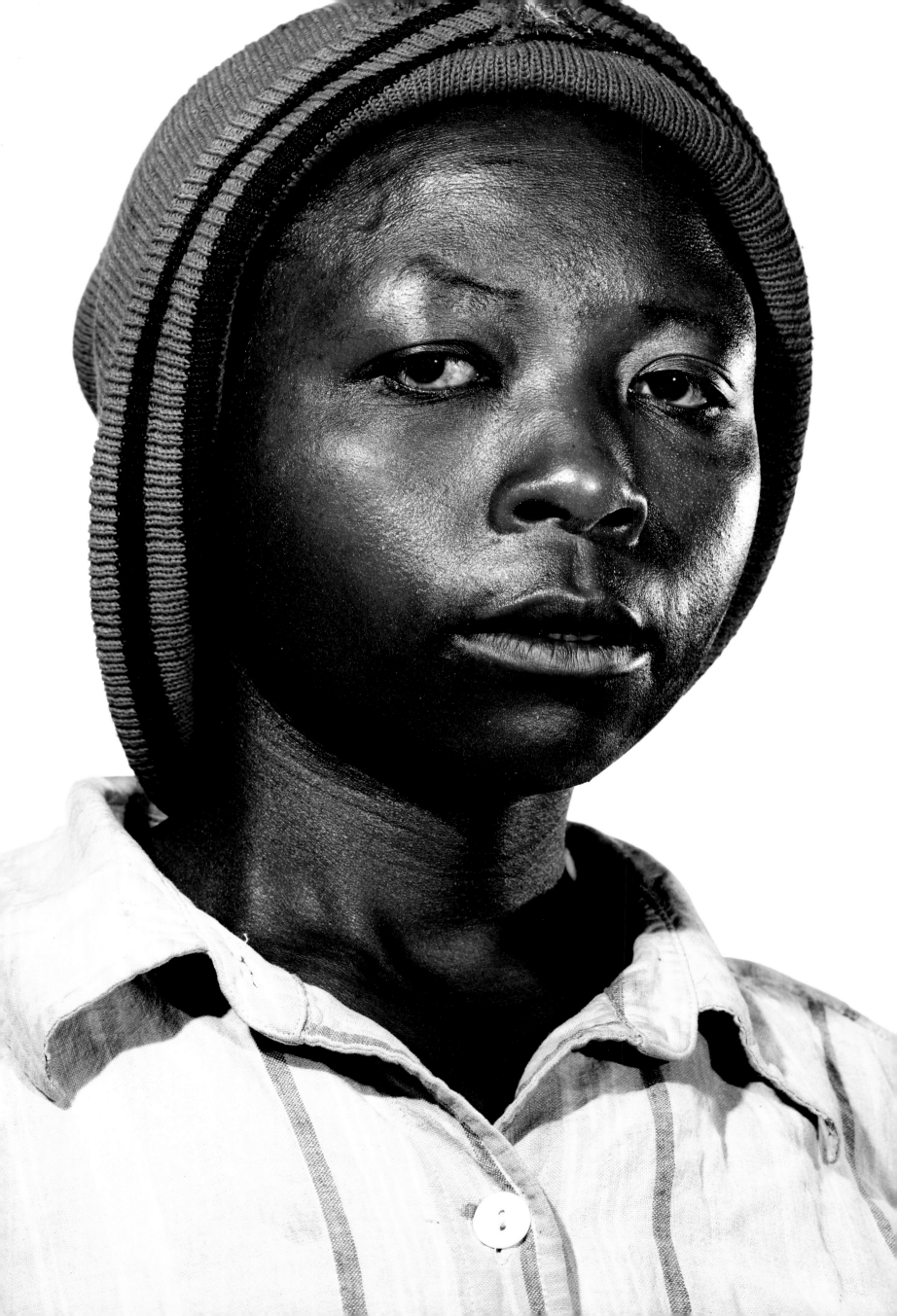

Peace is when I
and my family have
something to eat
and wear. That is when
I can feel peace.

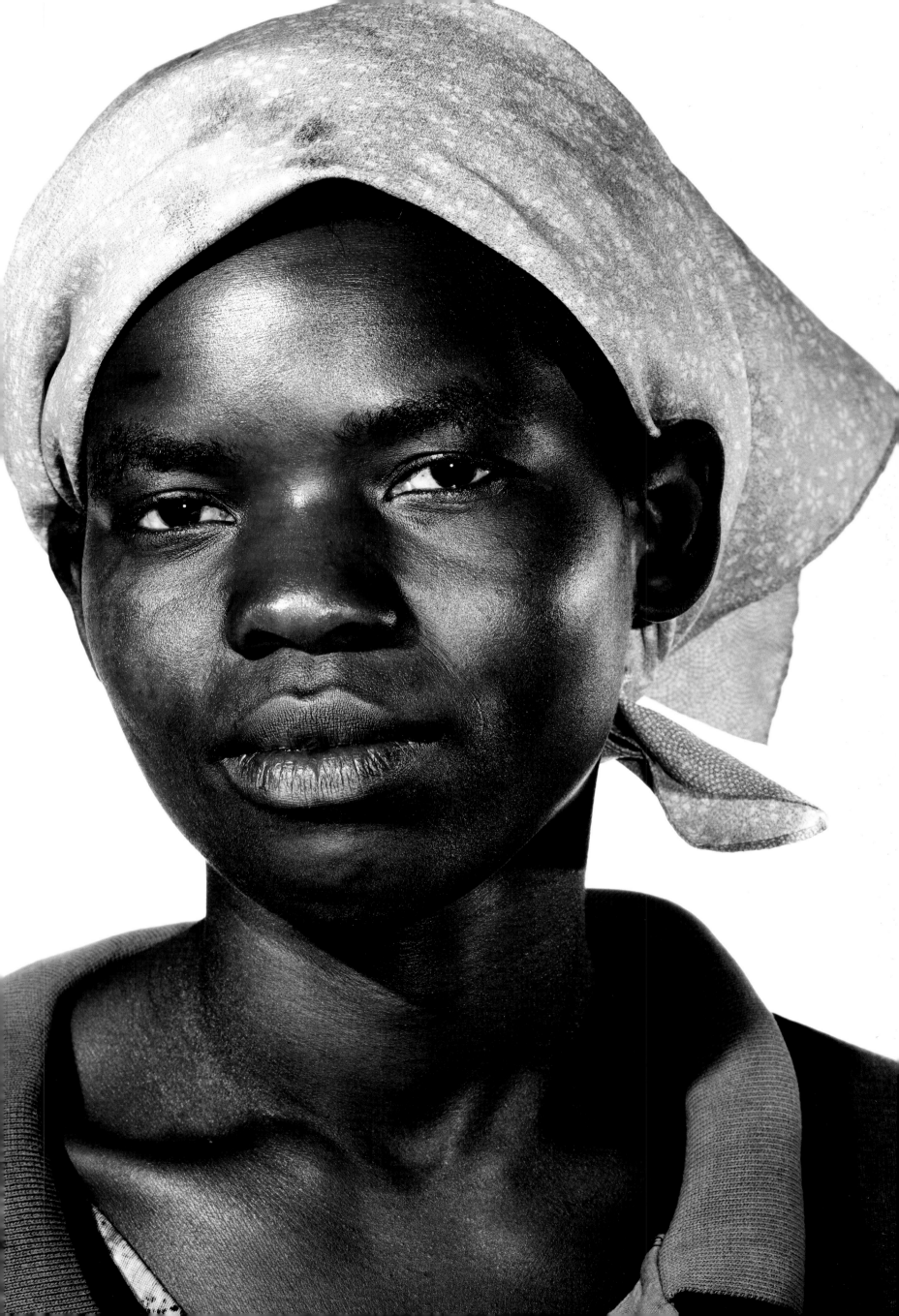

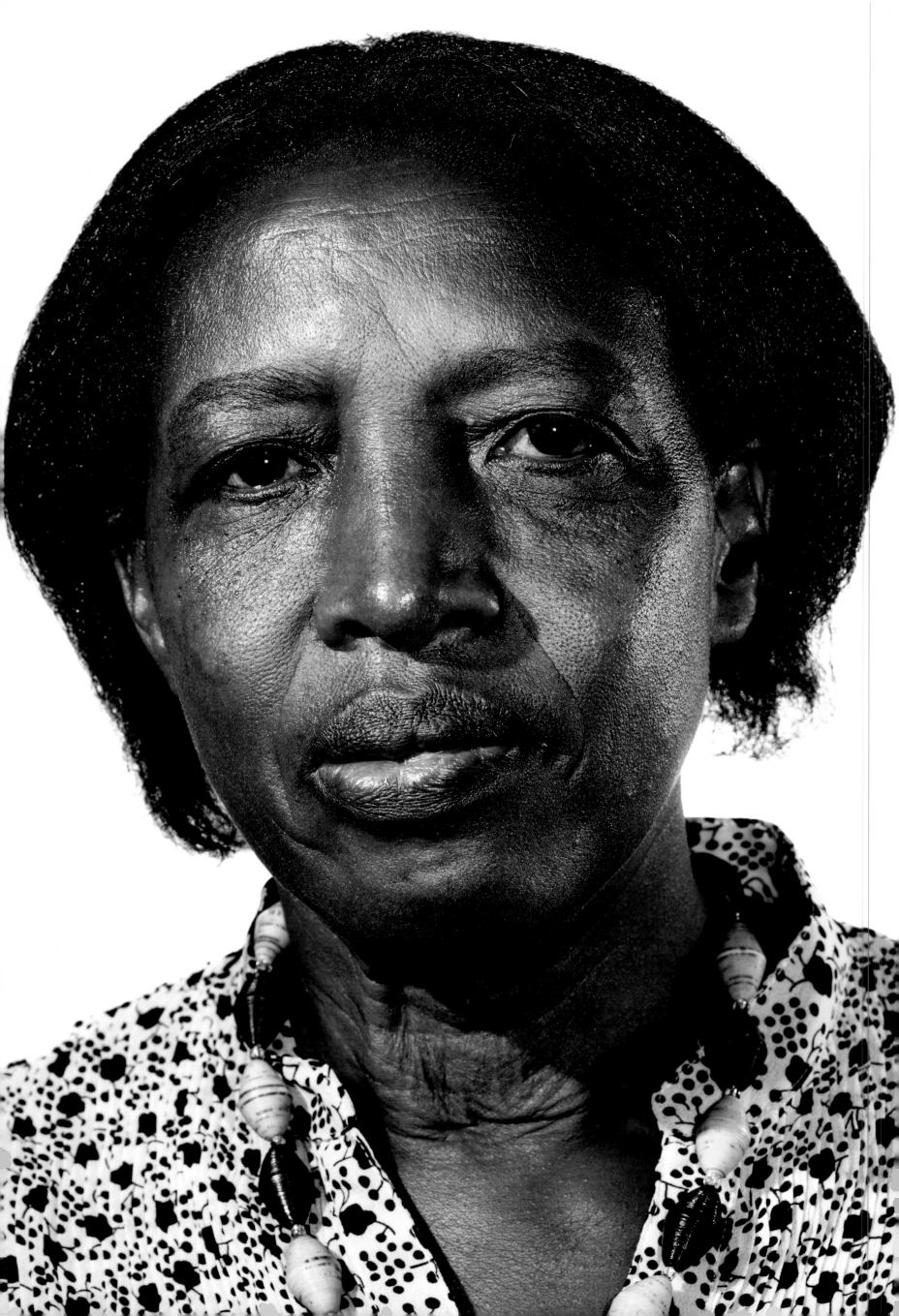

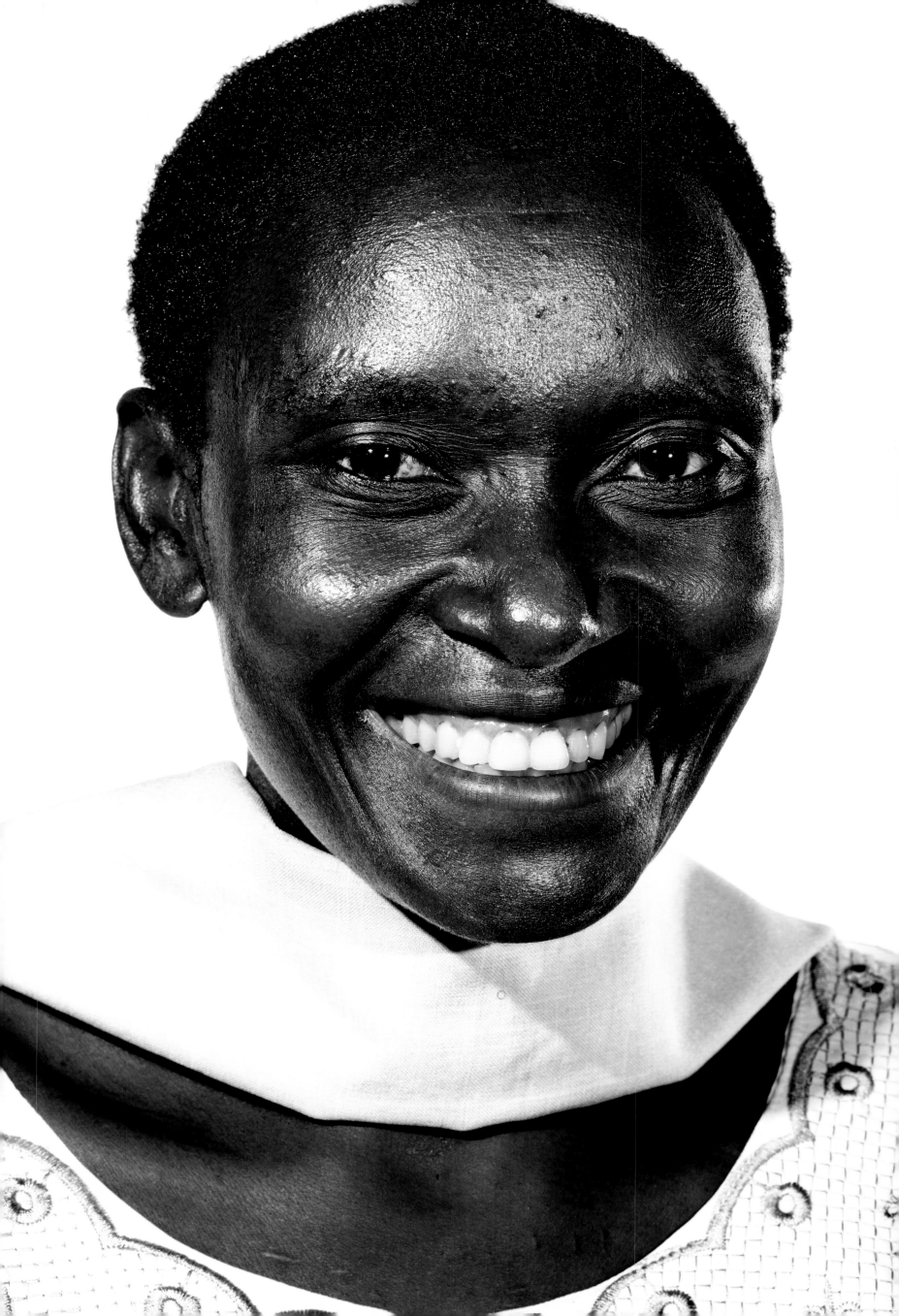

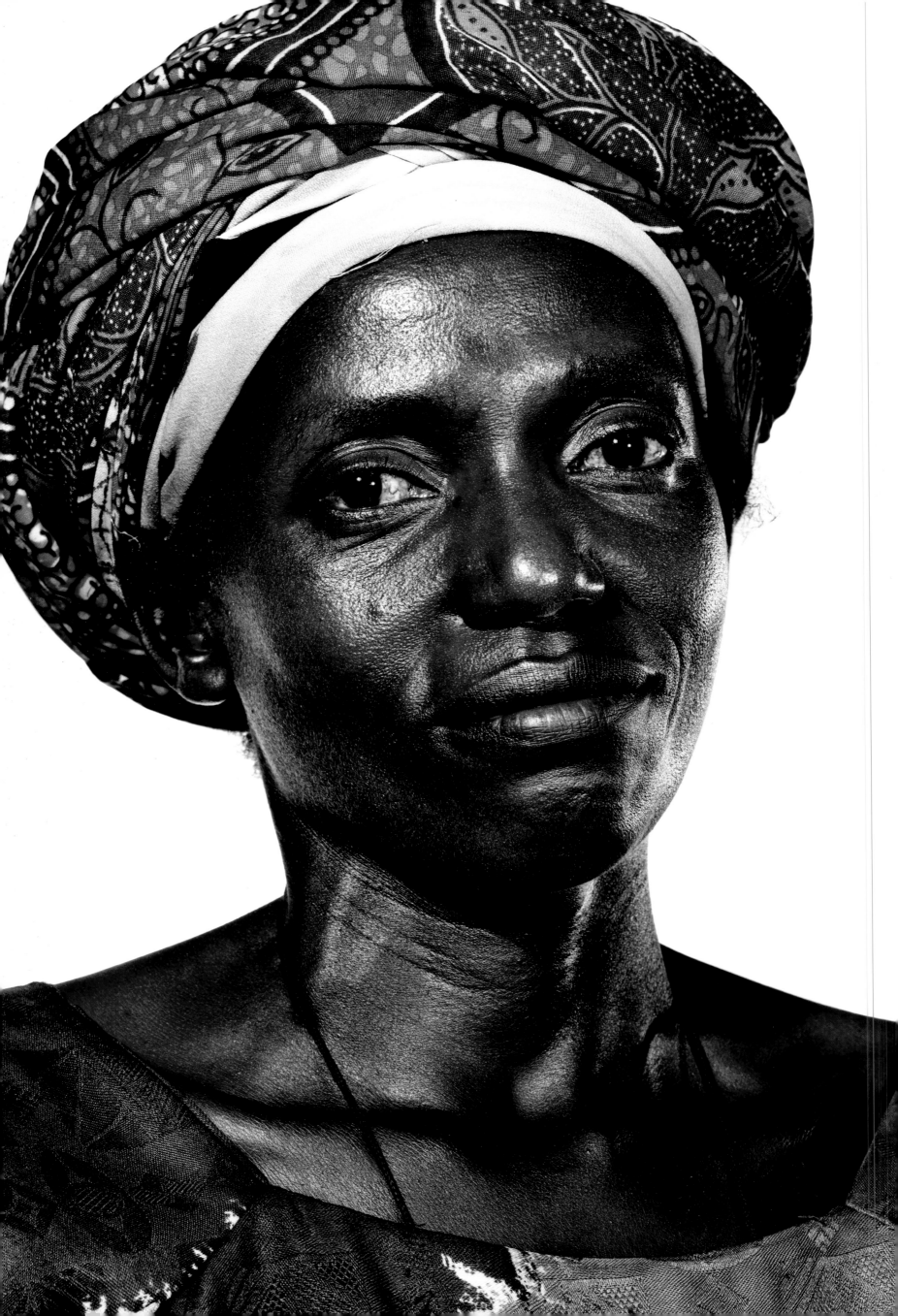

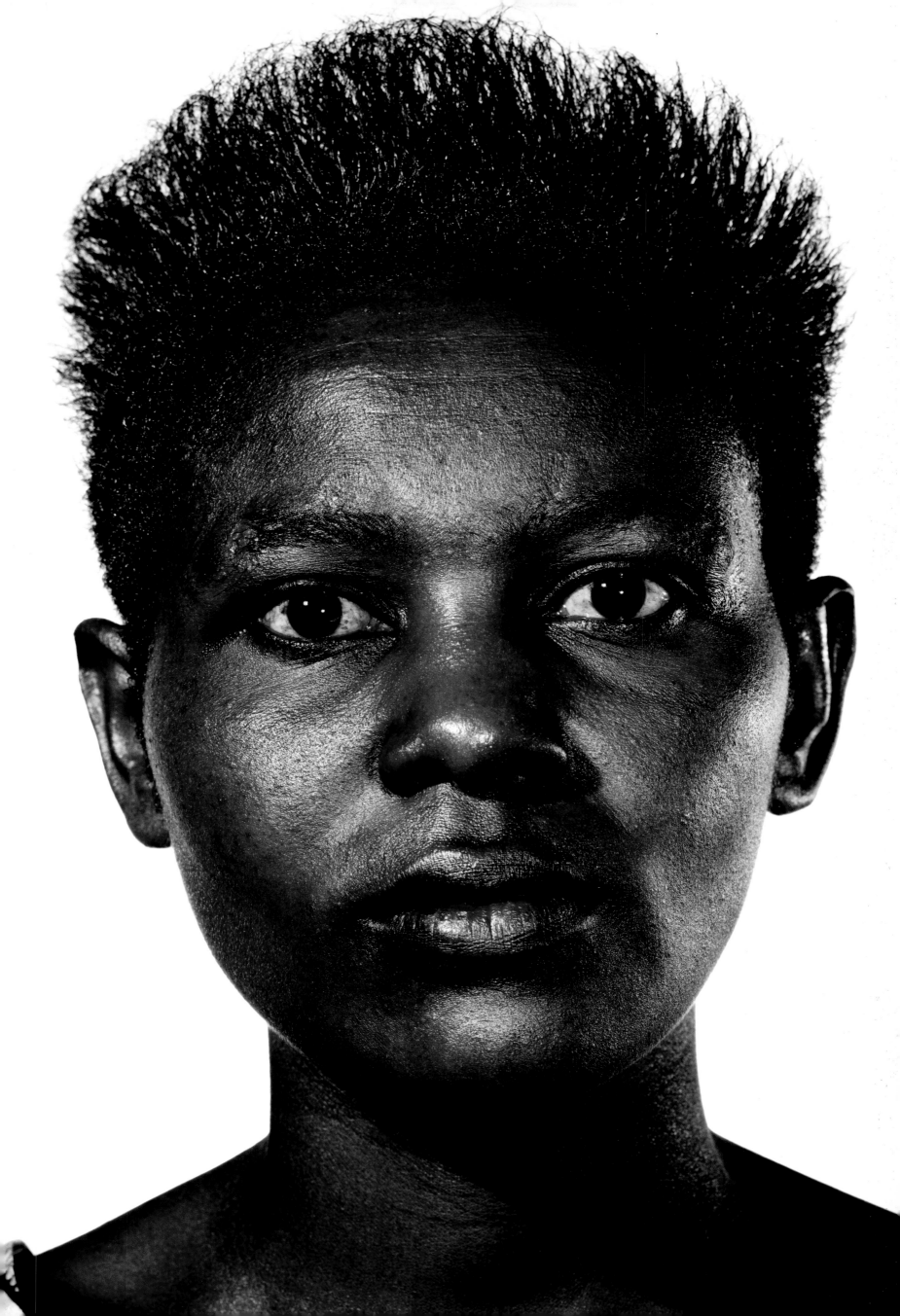

My name is Annonciata

I was born in 1958. I have four children but no husband. And all my children are married. I live alone with my mother.

The year that I was born, Rwanda was in the midst of genocide. The lucky managed to escape. We were not so lucky; my father was killed, leaving only my mother to look after my brother and I. I had to drop out of school after grade five because my mother wasn't able to pay my school fees.

I had dreams though. I thought that I was going to finish my schooling and work as a minister in the government. I wanted to become a big personality in my country. Unfortunately, I didn't have that chance. I laugh when I think back on that now. My dream didn't come true and it is now too late for me.

I was 16 when I left school and started to farm. Then, the time came for me to get married. My husband used to be my neighbor. Our families were friends. And he came to my parents to ask if he could marry me. My family agreed and we were married.

I loved him.

And now, I rarely remember my husband, because everything seems so much to be in my hands. I do everything alone, without support. And yet he used to be there. It is really very hard for me. I find it tiring and lonely. I have to think of everything and solve all of my problems myself. I feel as though I am all at once a child, a mom, and a dad. I'm everything.

He was killed during the genocide. We were living in Kigali and I had gone home to visit my family. While I was away, the genocide happened and he was killed, along with my 12-year-old son. And by sheer luck, I managed to escape.

I returned to Kigali to find my husband and my son dead. But my daughters were alive, thankfully. I stayed with them for a while on land which we owned in Kabuga. But the president—it was Bizimungu at the time—he bought our land. So I decided to move back to my parents' home and take care of my mother; I was a widow and could not manage to live alone in Kigali. Life was expensive and I had lost my brother too. So, for me, staying in Kigali was impossible.

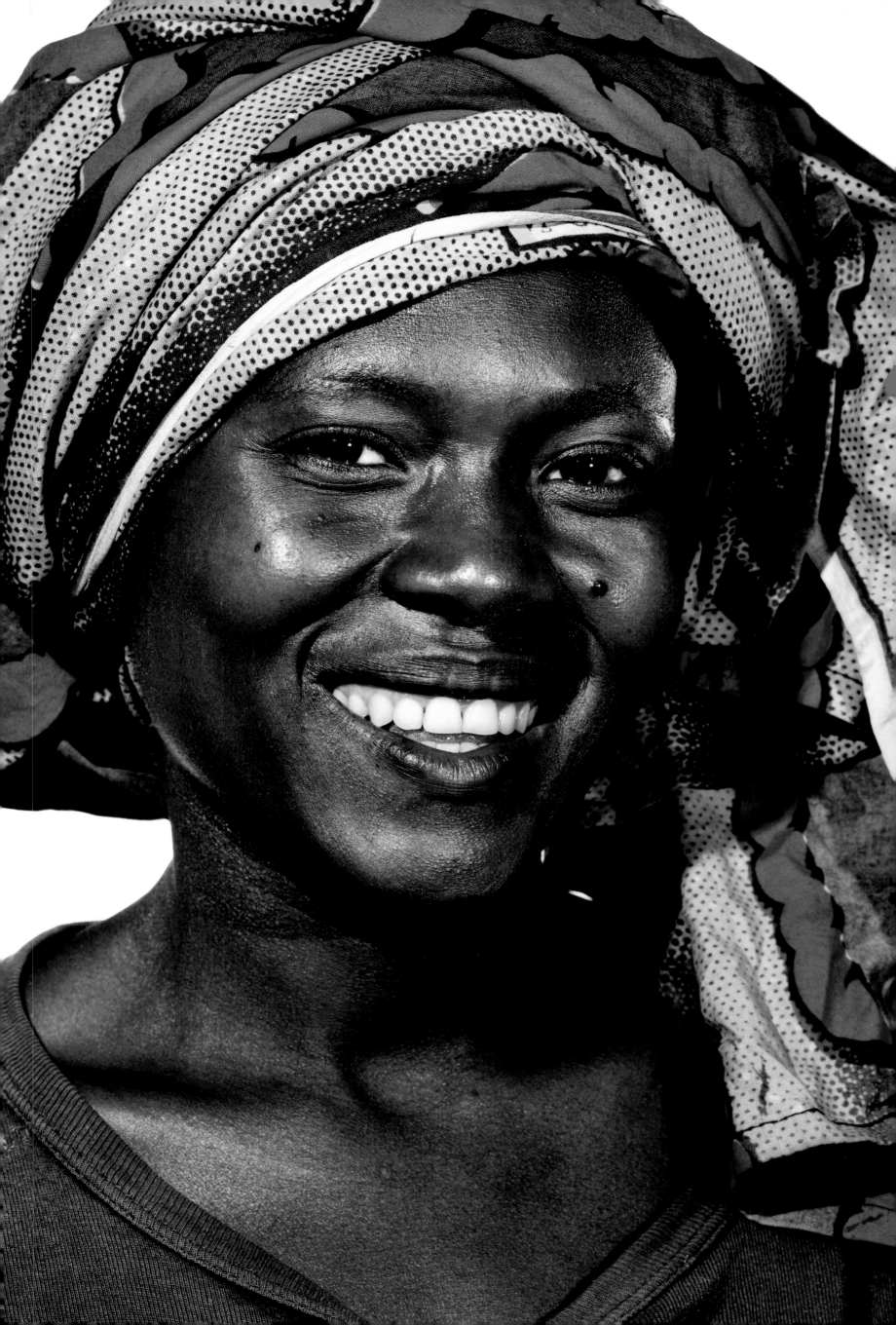

I have seen war with my own eyes. I have seen people killing each other. I saw people running out from their homes. I have seen people searching for missing family members. War is something that is really, really bad!

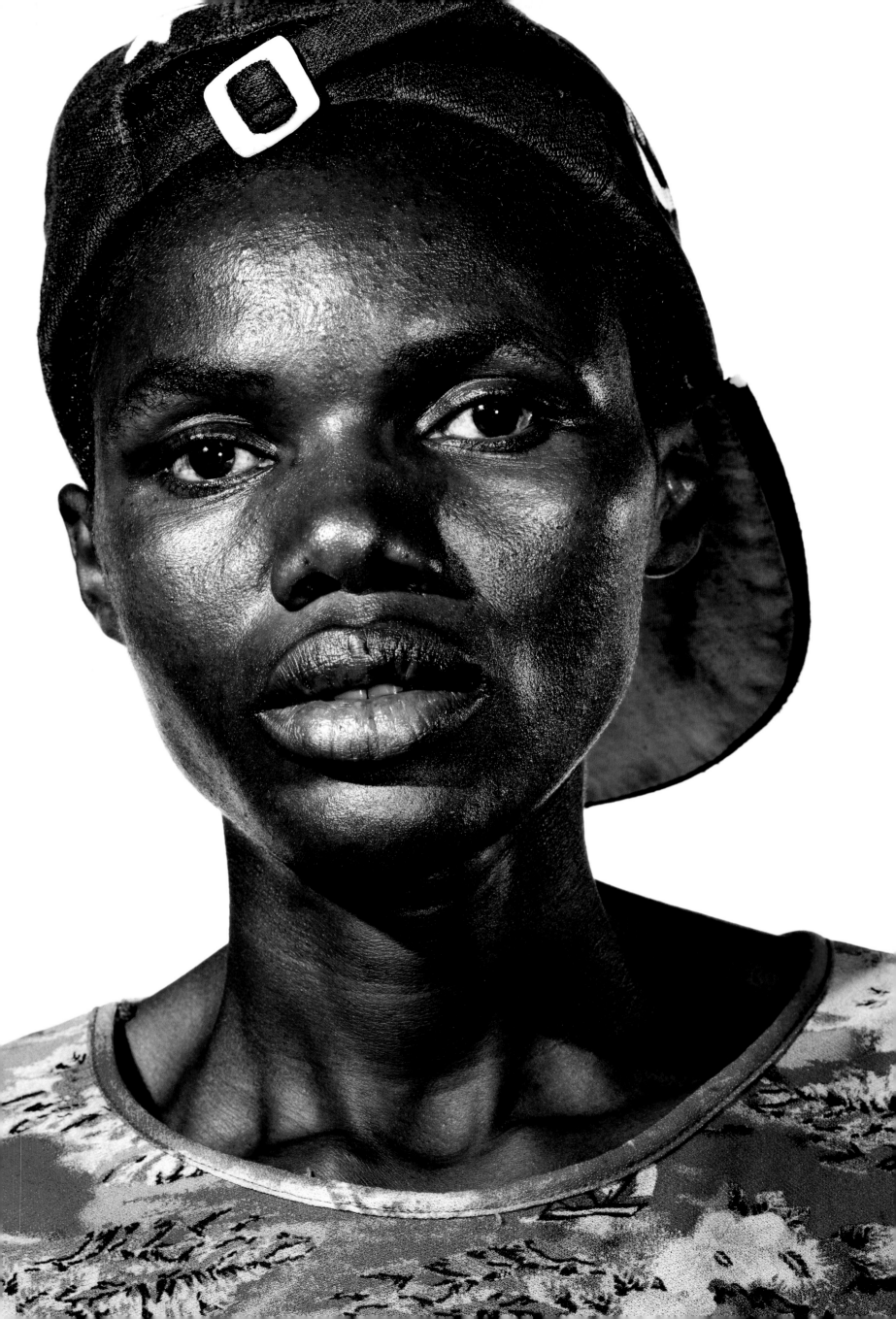

Bosnia and Herzegovina

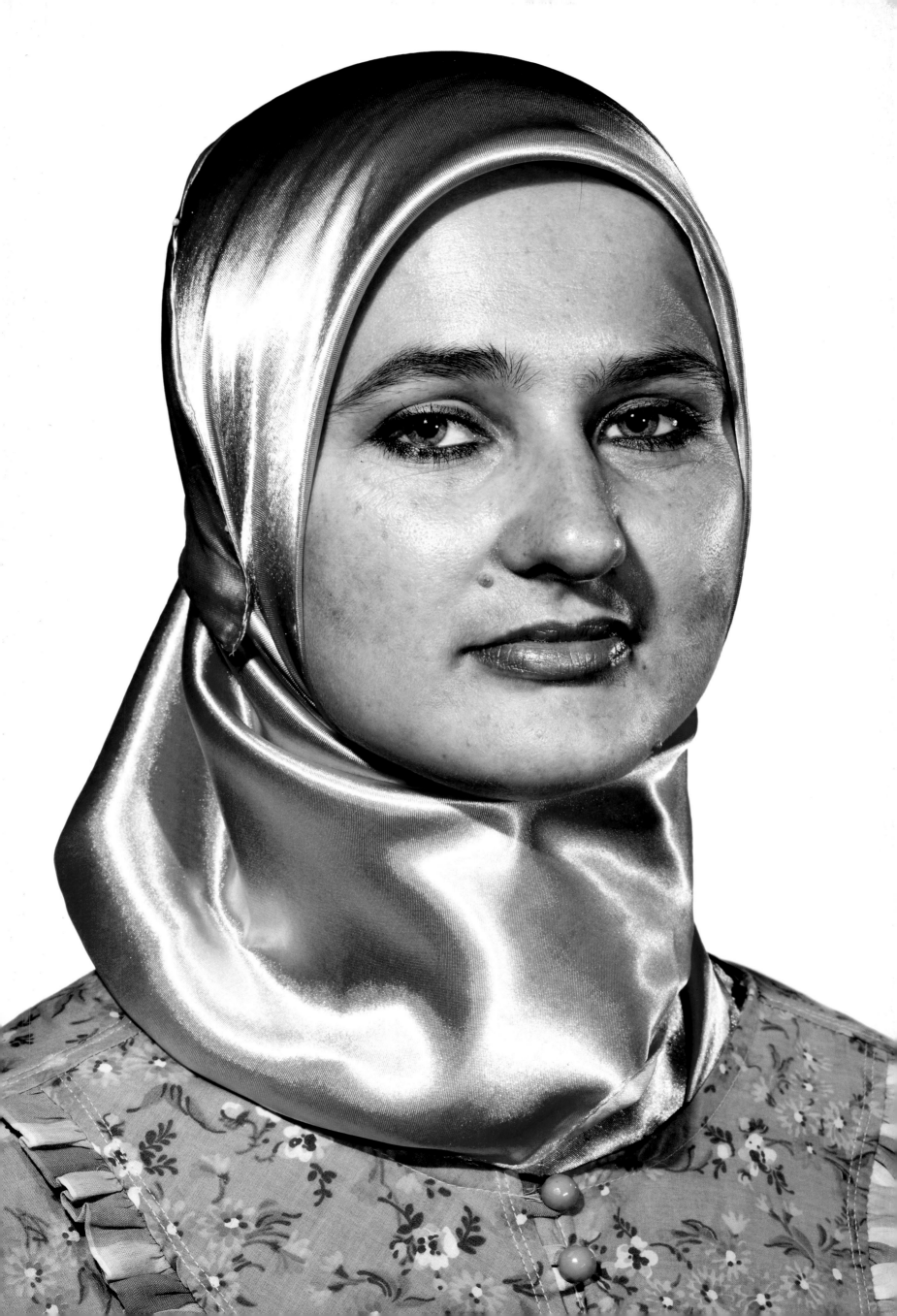

My name is Sadzida

And I don't count my years. Just joking. I am 48 and I am probably soon going to be 50.

I got ill in 2005. I thought it was the worst case scenario and I don't like to remember those moments. On my way back from the hospital, a friend of mine told me that an organization, Women for Women International, was on its way. I don't know why but something about it attracted me. Maybe the name, "Women for Women." I don't know really what it was exactly. So, I was coming back from Mostar, and I didn't go home straight away. I went a couple of hundred meters further, straight to the museum, where the organization held their presentation. I heard only half of it; the other half I didn't hear because I was so worried about my health at the time. I had fibrocystic breasts, and when I went to some information sessions about women who actually did have breast cancer, it comforted me because I knew then that I didn't get my worst case scenario after all.

Then I saw women making these baskets. I liked them, but I decided that I could make them better by decorating them. It is really hard work, even hard for a man, but I can do it. Women for Women in Sarajevo saw my determination and so I just started making them. At the time, I didn't really do it for the income; I just wanted to forget about my health problems. And at one point I realized that I had something close to 300 baskets and I had filled the whole room with them. Friends of mine from Austria came and I was supposed to go to the seaside with them. We decided to put all of the baskets in the car and take them with us on our summer holiday. And it took us only half an hour to sell all of the baskets. And to think that everyone had originally said to me, "What are you going to do with all of those baskets?" I was the happiest woman alive. I had my wallet filled with all of these different currencies of the world: dollars, Australian dollars, euros, pounds, everything. I had managed to earn the equivalent of my husband's monthly salary.

And so I decided to share my joy with the women in Sarajevo. So that is basically how I got started. The group gave me a job to educate and instruct 60 other women, to train them to make and decorate baskets. It was my greatest joy when those women started making an income.

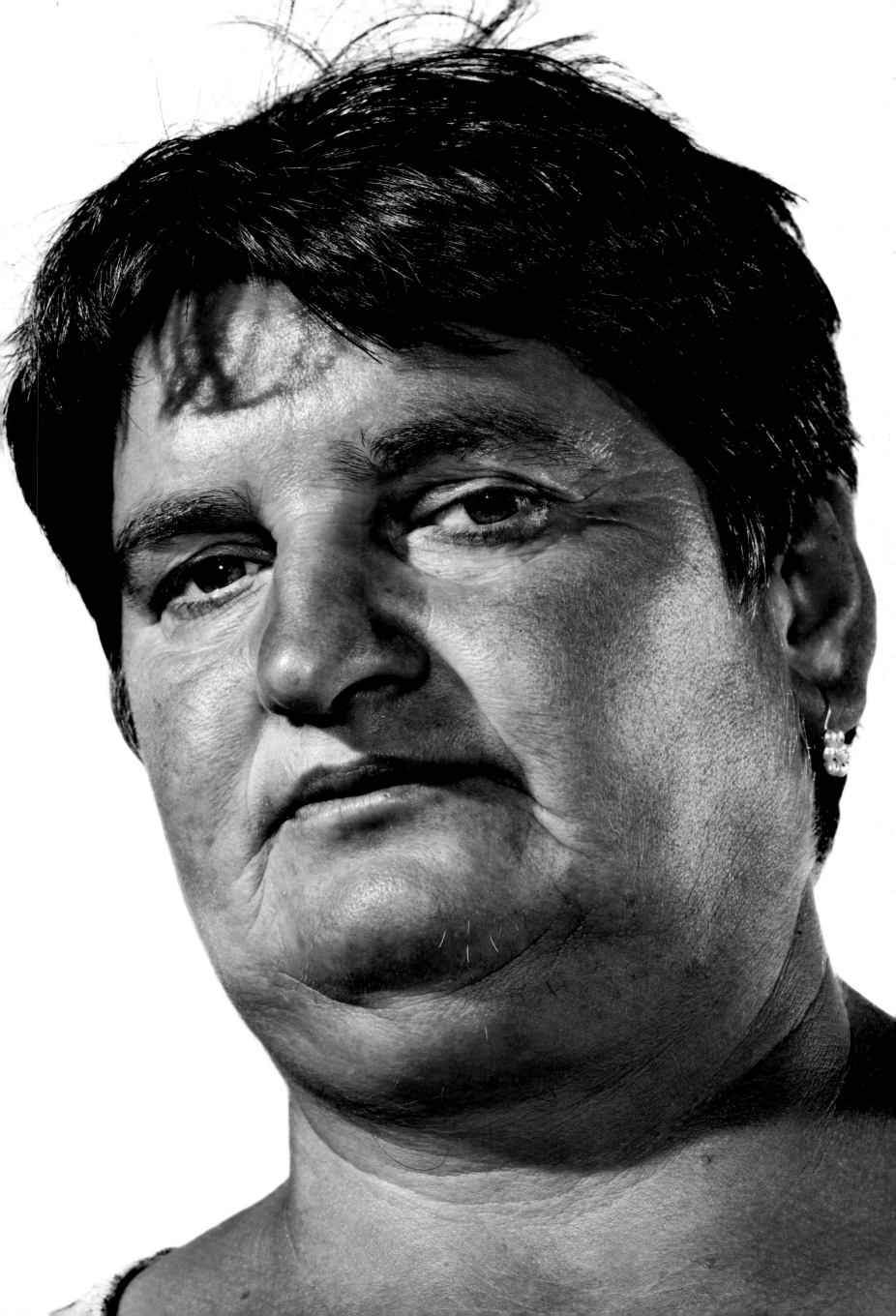

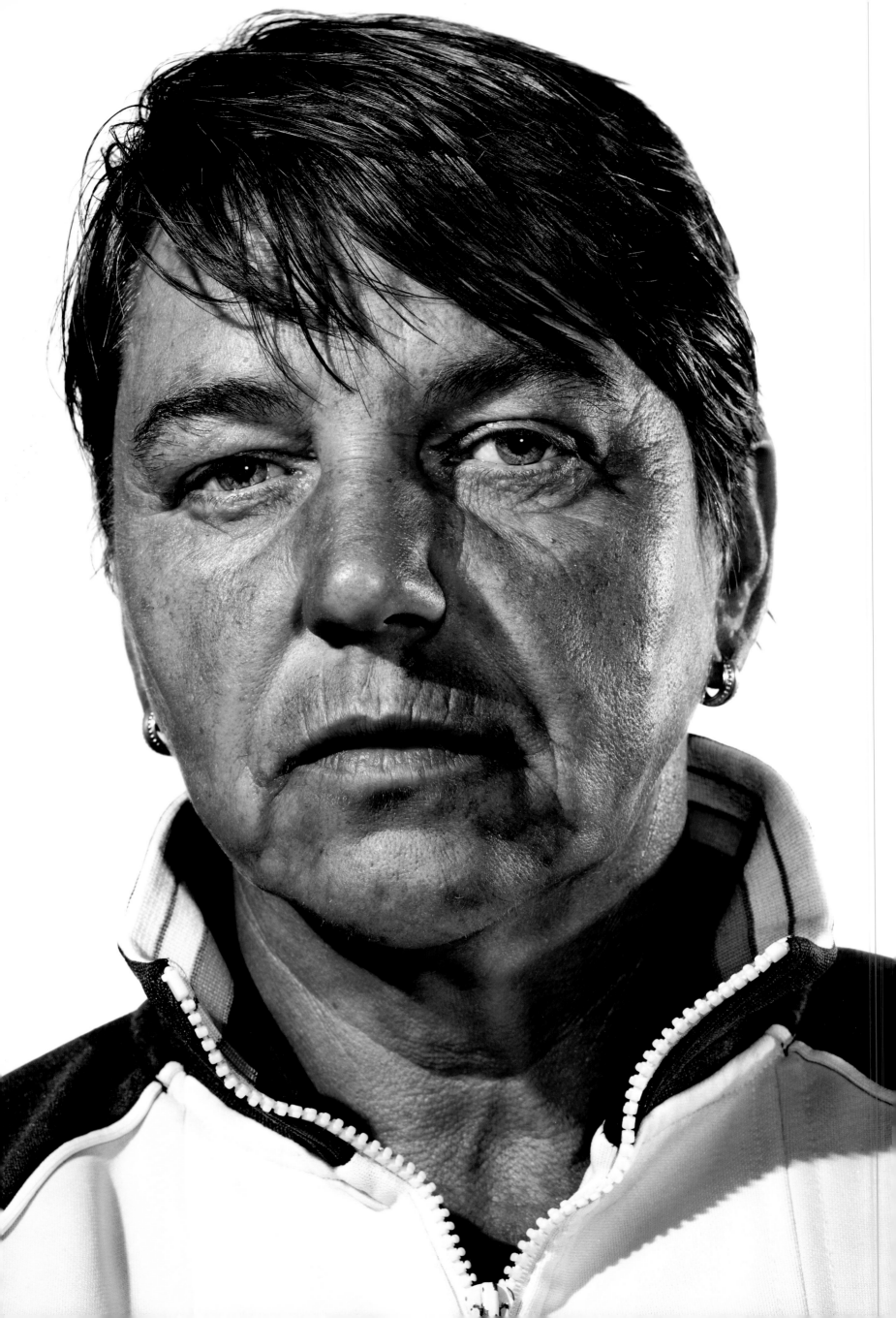

I came back to the town
where my family was killed
in spite. I came back in spite
of seeing my brother tortured
and his eyes popped out.
I came back in spite of seeing
my mother's brain burst out.
I came back in spite of
being forced to clean the floors
and windows of blood. I came
back in spite, to tell them
I am still alive. I exist. And
I hold the story. Do you have
any other question?

I hope that we will have peace, I hope we will have enough work and jobs, I hope we will have enough love, and I also hope the government will think more about us,
the people, living in the villages.

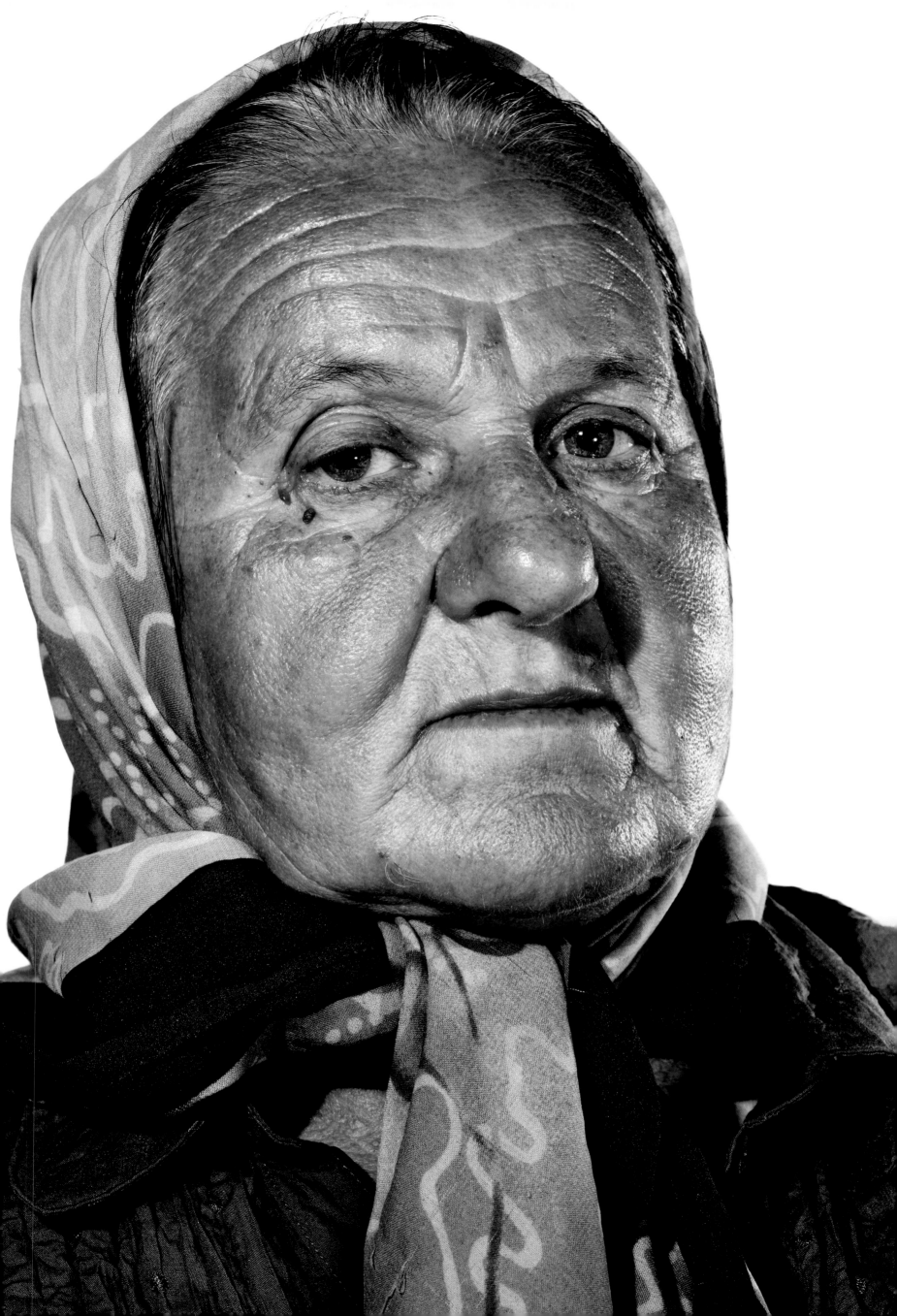

My name is Zahida

My last name, Dudic, is one that I got from marriage. Even though I am divorced, I have never changed it back. I have a son and a daughter and my wrecked marriage has actually yielded some good.

I was born in 1960, which was such a long time ago. I had such a carefree childhood. I'm a really emotional person in general, so the outlook that I have on my life, both looking back and looking forward, will sound like poetry. And I don't want to be falsely humble. So I will say freely that I am a really generous person and I chose to live my life like that. I have two sisters and two brothers. Both of my brothers had to have a leg amputated after being injured during the war.

I graduated from high school and I wanted to continue with my studies, but my father got really ill and we were not in a very good financial situation. So I could not continue with my education and I got married instead. That turned out to be one of the biggest mistakes I've ever made in life because I didn't choose a good spouse.

I met him at my cousin's place. It was a completely accidental meeting and we dated for just a short period of time and got married very young. I was only 20. And I didn't leave until 28 years later and I'm really ashamed of that.

The marriage was bad from the beginning. But I hoped that people could change. I thought that if I was positive towards him, he would change; I believed that if you treated people in a positive way, then positive things would happen. That is what I hoped. But that was my biggest mistake. What it really did was to encourage him to do whatever he wanted to do.

He drank a lot and he was very aggressive and very impulsive, even though I am sure that he did love me. But that was not enough. He was this way from the beginning, even as a young man. And it became worse during the war.

We had been married 11 years when the war began. I was really afraid for my family, for my children. My mother and brothers became internally displaced people. And it was my duty to go and see them and to cook and clean for them. There were no phones so I would need to go see them to check that everything was okay with them. My life was so stressful and so tumultuous, but one memory clearly stands out as one that I would gladly erase from my mind if I could. One day, I went to see my mother and she was with

Peace is liberty. You are free to do whatever you want and, when you have peace and when you live in peace, that means satisfaction.

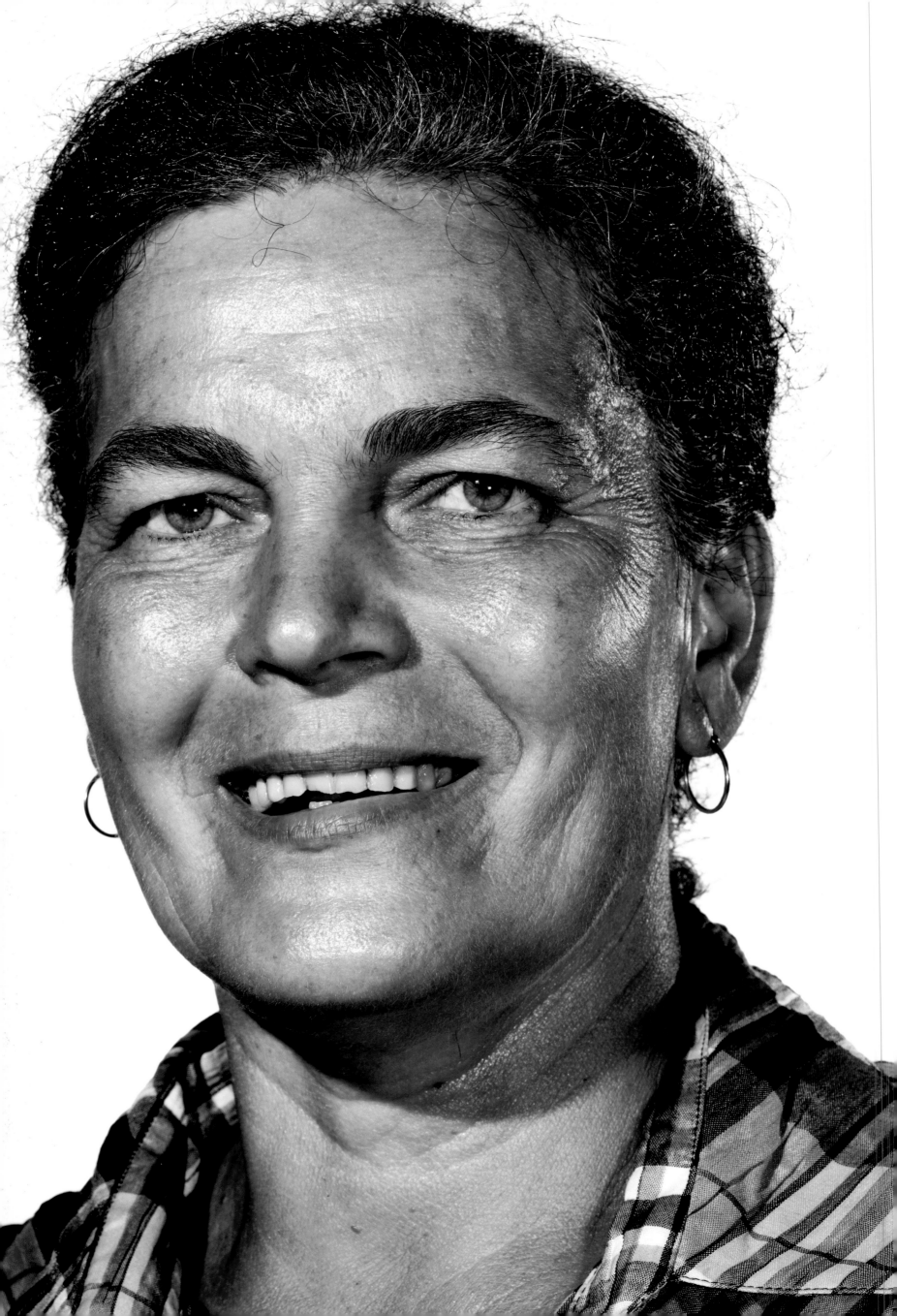

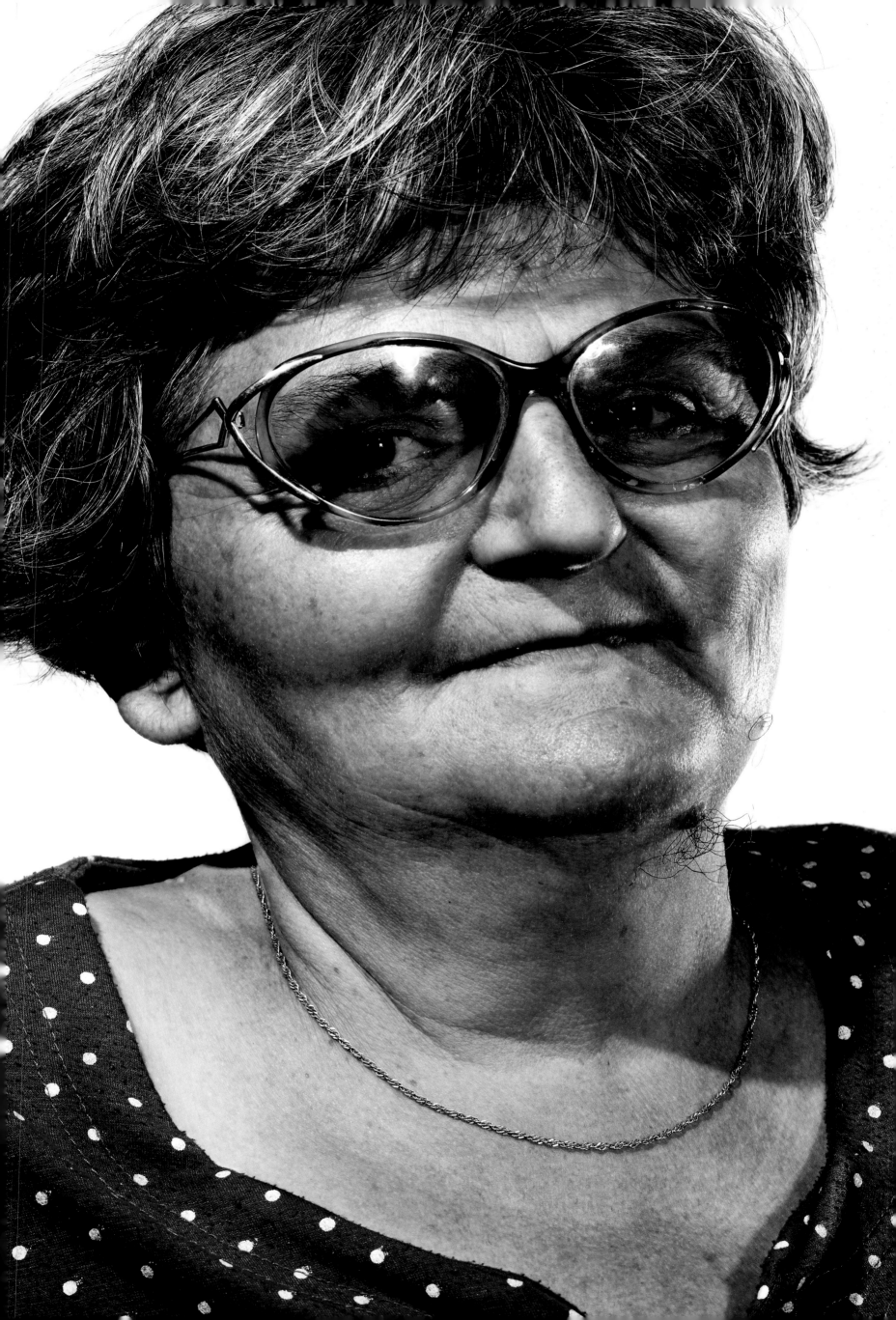

My name is Rasema

I was born in 1961. My childhood was very poor, and there were seven of us. I went to school. I wanted to be so many things. One of them was to go to the traffic technology school and do street designs. But, unfortunately, I didn't have the proper conditions for that. We did not have the financial opportunity, just like my children don't have today. They have all finished high school but they cannot afford to continue to go to university.

So I only finished elementary school and when I was 18, I got married. He was my first love. He was a brick man and he lived in the neighborhood, just a few houses down. It was true love and he was also very kind to me.

I couldn't conceive a child for a few years. Apparently I'd eaten some sort of bacteria, found in milk or meat, so I had a lot of miscarriages. And I had to go to Sarajevo to get treatment. Luckily, after the treatment, I could conceive, and when I was 21, I gave birth to my daughter, and when I was 22, I gave birth to my son. And when I was 33, I gave birth to another son.

Giving birth to my little girl was one of my happiest and most memorable moments, because the doctor had told me that I could not have children and then God gave her to me. When they brought her to me I couldn't believe she was real, so I unfolded the blanket and checked her little feet and her little hands to make sure that she actually did exist.

My memories from the war are filled with bitterness and horrible, horrible experiences. My husband went to the front line. He was in the army of Bosnia and Herzegovina. I was pregnant with my youngest son (who was born in 1992). The hardest moment was when I gave birth to him, and we came home and we didn't have anything to eat. We didn't even have flour. But at least God gave me enough milk to breast-feed my son.

Besides my newborn baby, I had also two other small children and only God knows how we survived. We only had bits of bread to eat. And I remember once my husband came back from the front line and he brought a bag full of old pieces of bread just so we could have something to eat.

The war left me with the worst memories of my life. But I have always had this life force that drove me from the inside. During the war, we would take whatever my husband could bring us from the front line. But after the war, we started working. We did not have greenhouses;

If you could get me a job, any job, taking care of children, of people, cleaning houses . . . anything, I would be so grateful to you because if you do not have a job, if you do not have your own money, you can't really do anything.

I have been through
war and displacement.
I have buried my father
with my own hands.
I have seen hunger and
poverty, and today
I am a fashion model.

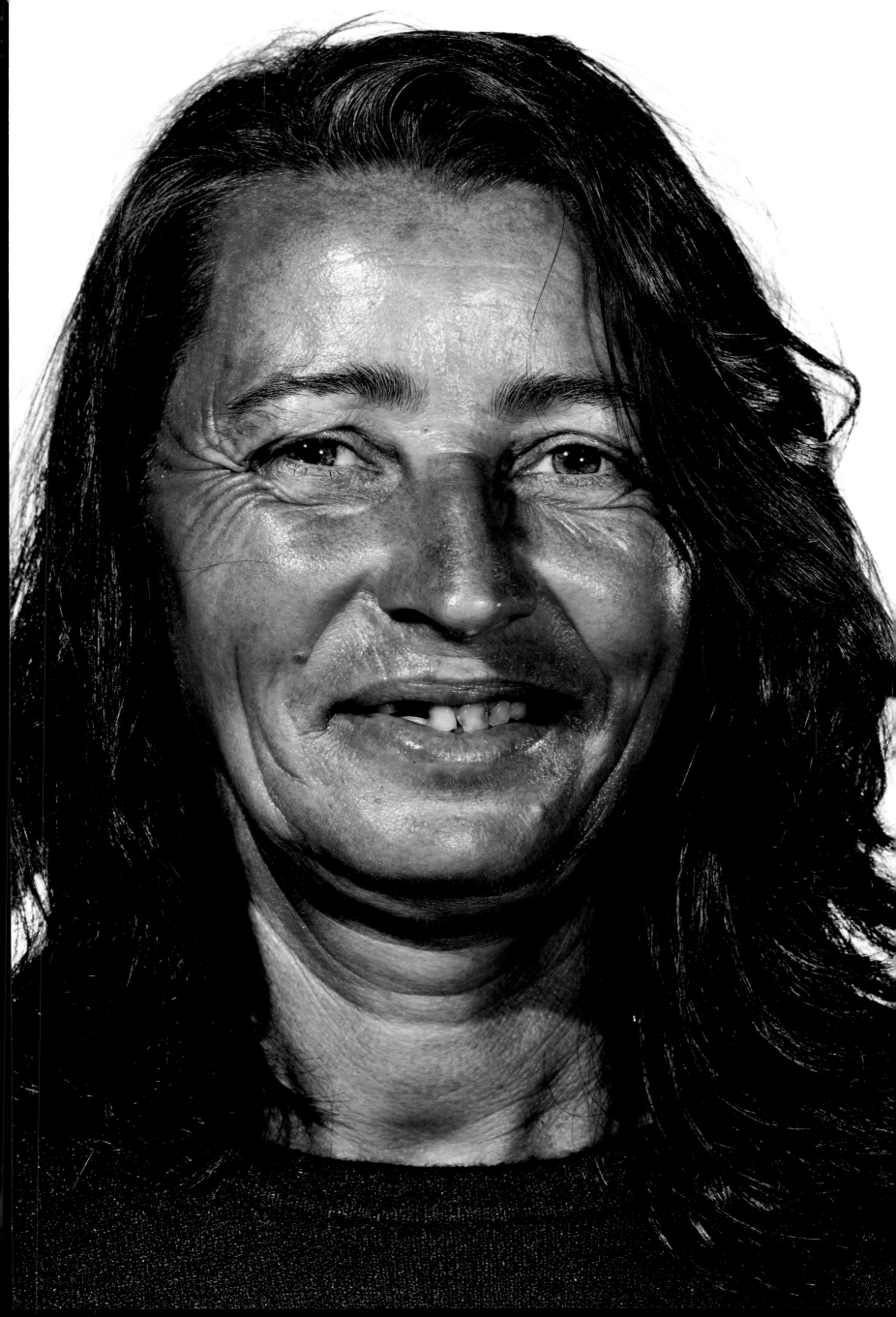

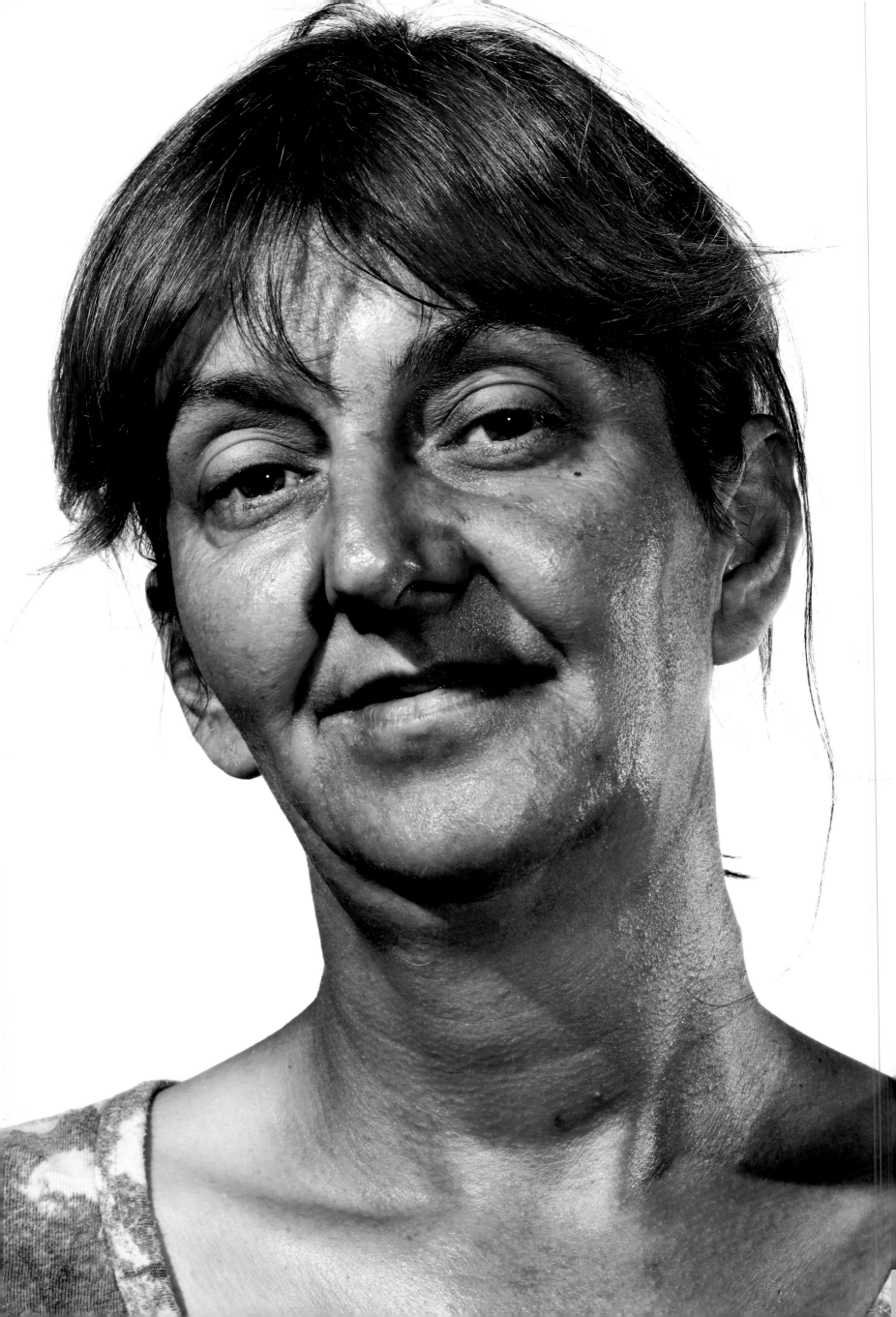

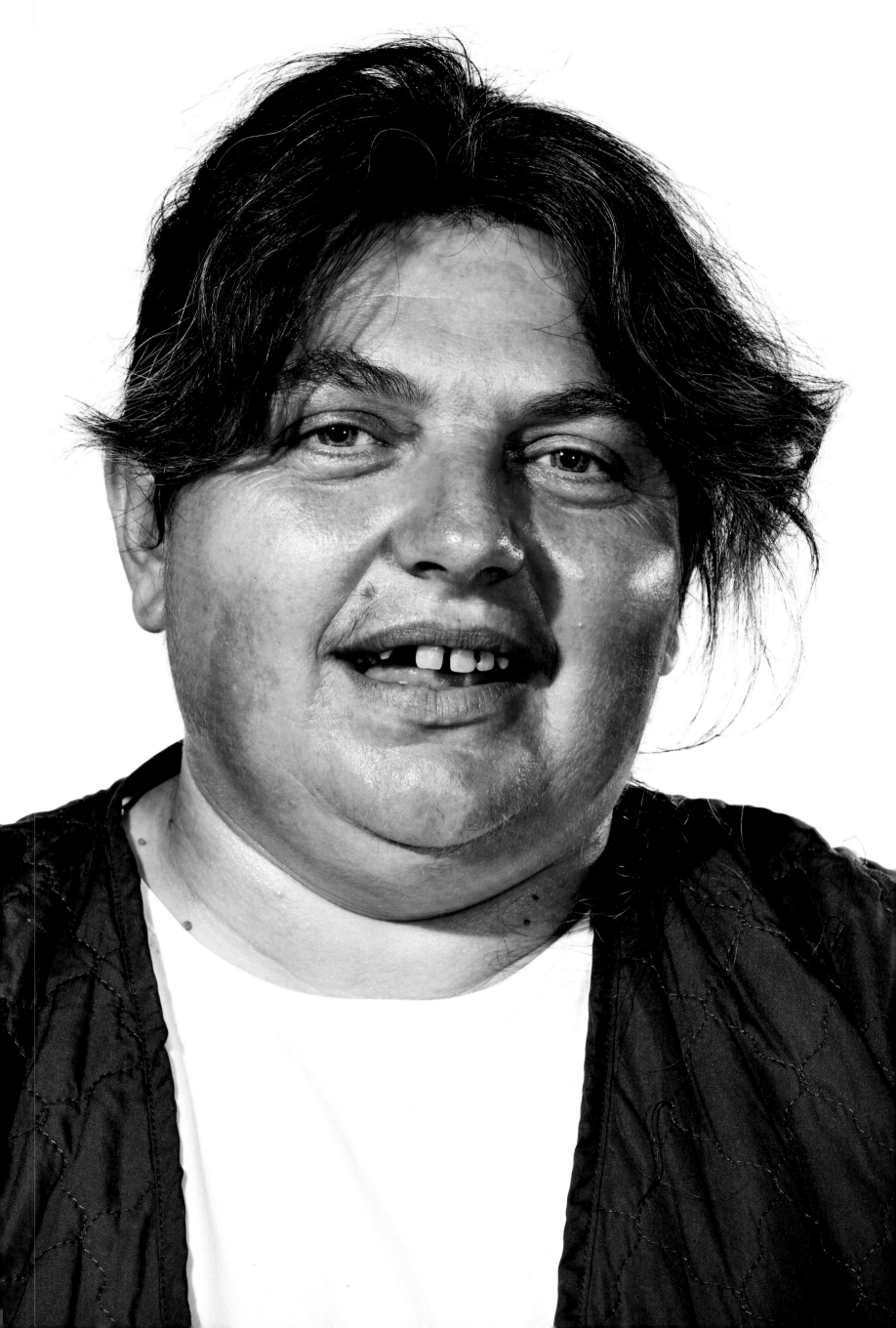

Peace, it's the
most beautiful
thing in the world.
It's freedom.
It's peace, it has
to be beautiful.

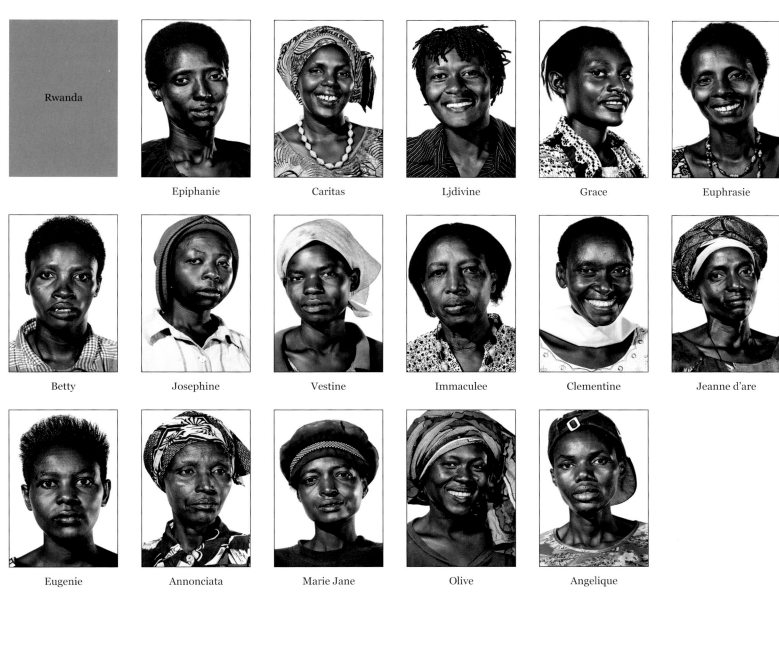

Rwanda

Epiphanie Caritas Ljdivine Grace Euphrasie

Betty Josephine Vestine Immaculee Clementine Jeanne d'are

Eugenie Annonciata Marie Jane Olive Angelique

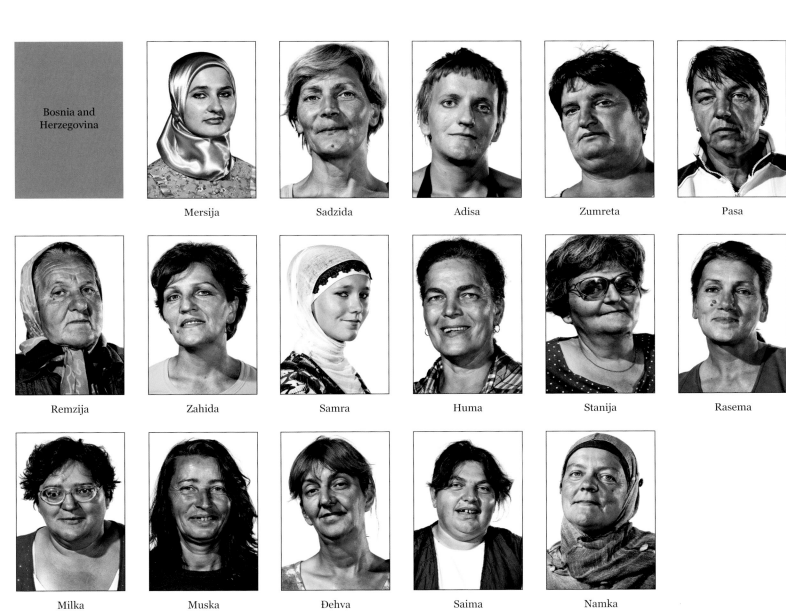

Bosnia and Herzegovina

Mersija Sadzida Adisa Zumreta Pasa

Remzija Zahida Samra Huma Stanija Rasema

Milka Muska Đehva Saima Namka

Acknowledgments

This book would not have been possible if it were not for the courage of each of the women who spoke up and agreed to tell her story. They have become my best teachers in life and have taught me the meaning of courage, resilience, generosity, forgiveness, peace, and joy. They have taught me to dance, to sing, and to stand up straight with dignity no matter the challenges life presents us with. Thank you!

Special gratitude to all of Women for Women International's staff and the leadership in each of the country offices: Christine Karumba from the Democratic Republic of the Congo, Sweeta Noori from Afghanistan, Seida Saric from Bosnia and Herzegovina, and Berra Kabrunja from Rwanda. Their determination to continue serving women in spite of a plethora of security and logistical challenges is inspirational and makes any challenge with a job in the U.S. pale in comparison. Thank you for your dedication to serving marginalized women and inspiring them to break their silence, speak their truth, rebuild their lives, and remember their value. You ARE Women for Women and my soul sisters in every single way. Thanks also go to all of the Women for Women International team in the U.S. and the U.K., especially Deborah David, Michaela Cook, Erika Lubensky, Teisha Garrett, Lyndsay Booth, Joanna Valdivieso-Gonzales, and Mary Wadlinger.

This book equally would not have been possible without the support of Jennifer Buffet from the NoVo Foundation who made many women's dreams come true throughout the world. Thank you for your support and generosity Jennifer and for making this dream a reality!

I am also grateful for the generous guidance of Maureen Chiquet and for lending me her expert eyes and a creative team to explore various ways of sharing the stories and portraits collected in this project. Barbara von Bismarck and Thierry Despont were essential sources of inspiration and support as we explored how to make this book a possibility. Thank you for organizing all the gatherings and the delicious meals you prepared as we explored the various possibilities for this project. Special thanks to Martine Assouline for her generosity in suggesting ideas for the look and feel of the book.

Tina Brown, Chief Editor of *Newsweek*; Joanna Coles Chief Editor of *Marie Claire* U.S.; and Antonella Antonelli, Chief Editor of *Marie Claire* Italy, were the first to see the power of the stories and portraits, and, with their support and coverage, gave us the confidence we needed to explore the full potential of the stories. Special thanks to Rachel Howald and Amer Khan for coming up with the title that captured the spirit of this book.

Gratitude to Meryl Streep, Annie Lennox, Geena Davis, Ashley Judd, and Angelina Jolie for agreeing to write the forewords and for all their wonderful work and support of women's causes around the world. Your voices lift all other women's voices and for that I am so deeply grateful.

And last but not least, a very special thanks goes to Maria Wang who worked diligently to edit all aspects of the book, Caitlin Parker for supporting the process of organizing the book and selecting the quotes, Yolanda Cuomo for her wonderful designs and fun spirit in the process of doing the work, and Craig Cohen at powerHouse for his support of the book.

IF YOU KNEW ME YOU WOULD CARE

All proceeds from this book are dedicated to Women for Women International.
To sponsor a woman, please visit www.womenforwomen.org

WOMEN *for* WOMEN.*org*

Published in the United States by powerHouse Books,
a division of powerHouse Cultural Entertainment, Inc.
37 Main Street, Brooklyn, NY 11201-1021
telephone 212.604.9074, fax 212.366.5247
e-mail: info@powerhousebooks.com
website: www.powerhousebooks.com

First edition, 2012
Library of Congress Control Number: 2012943155

ISBN 978-1-57687-619-0

Associate Book Designer: Kristi Norgaard
Separations by Robert Hennessey
Printing and binding by Editoriale Bortolazzi Stei SRL

10 9 8 7 6 5 4 3 2 1

Printed and bound in Italy

BOOK DESIGN BY YOLANDA CUOMO DESIGN, NYC